DISNEY

DREAMS COLLECTION

THOMAS KINKADE
S T U D I O S

DISNEY PRINCESS
COLORING BOOK

Andrews McMeel
PUBLISHING®

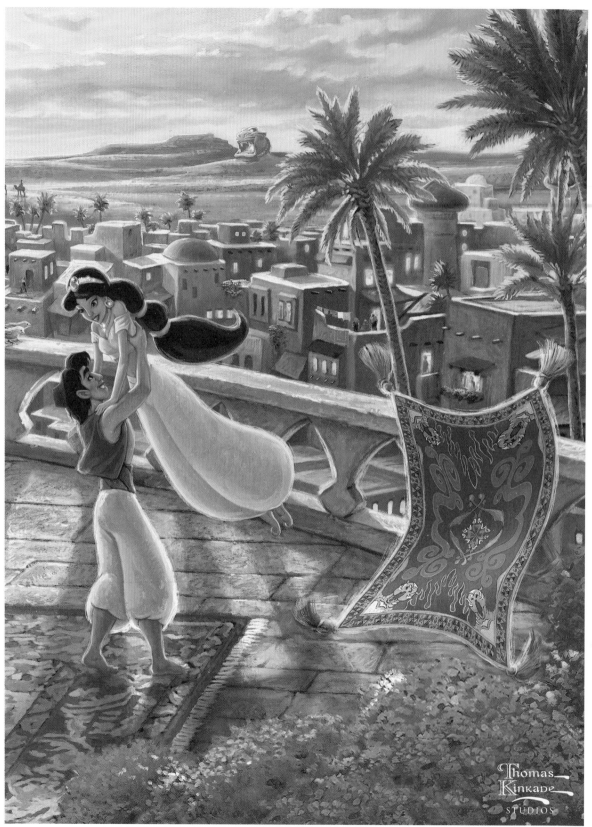

Jasmine Dancing in the Desert Sunset

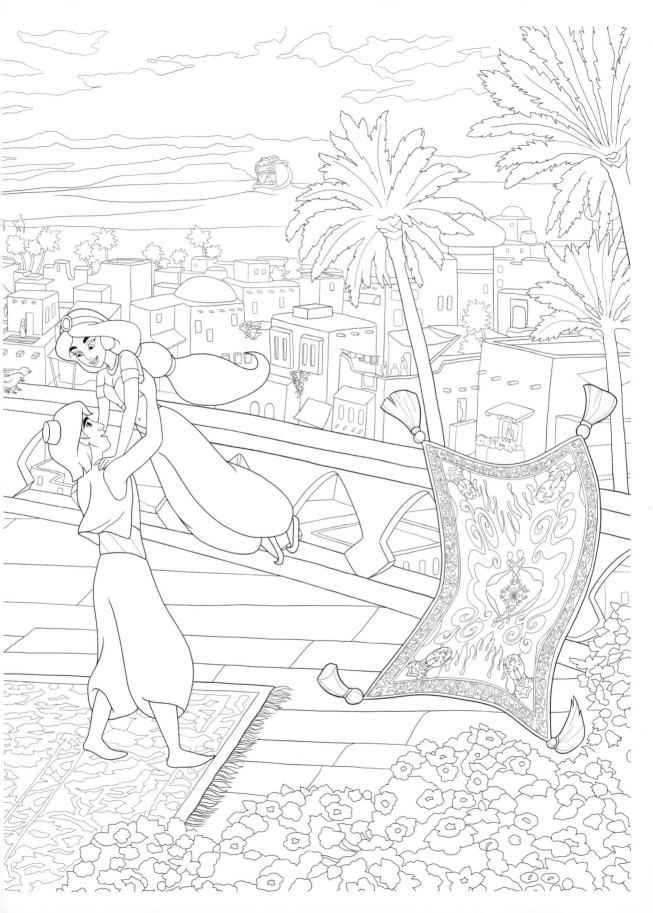

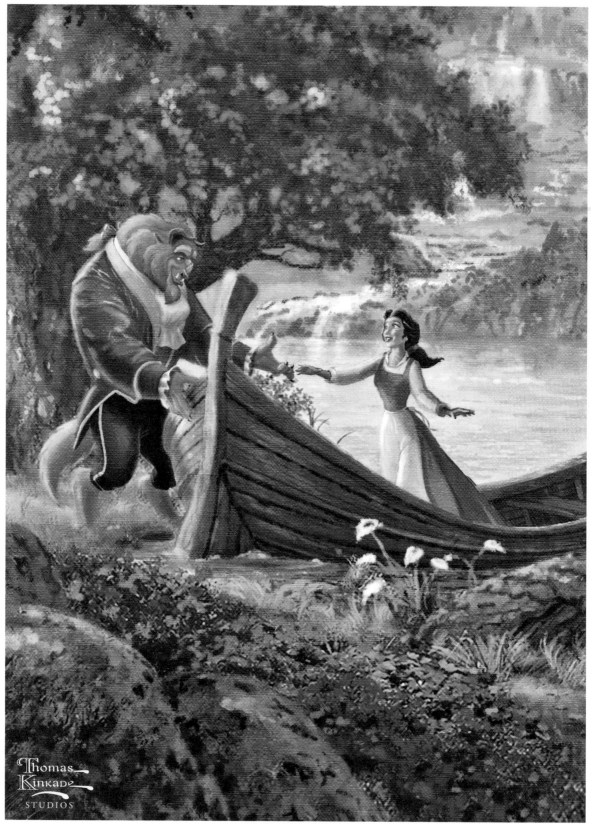

Beauty and the Beast II

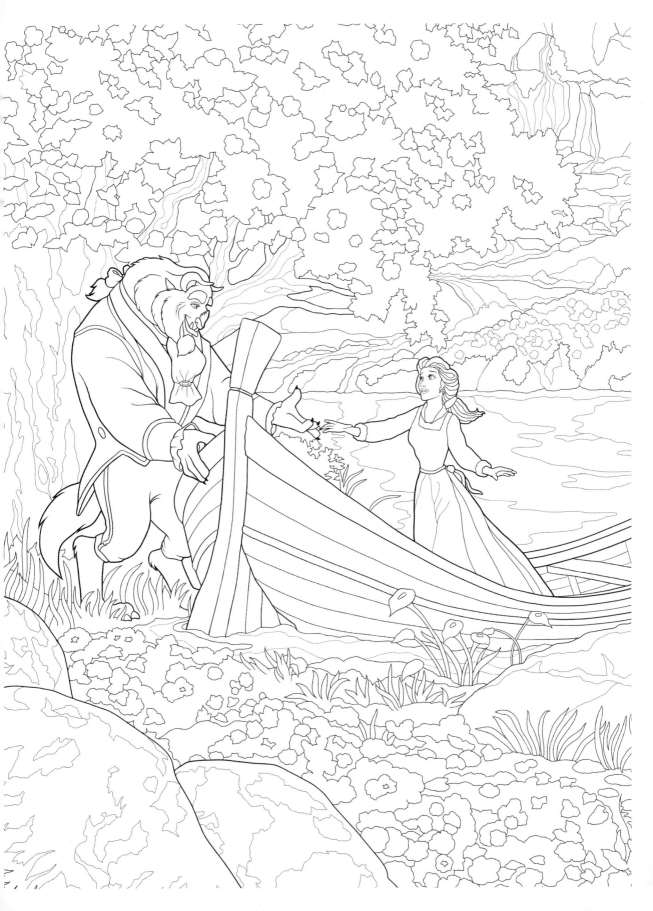

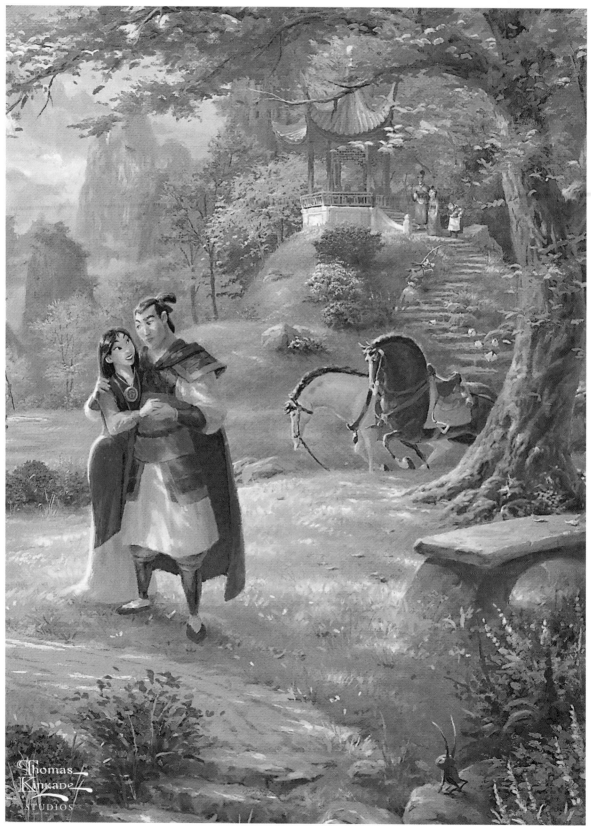

Mulan Blossoms of Love

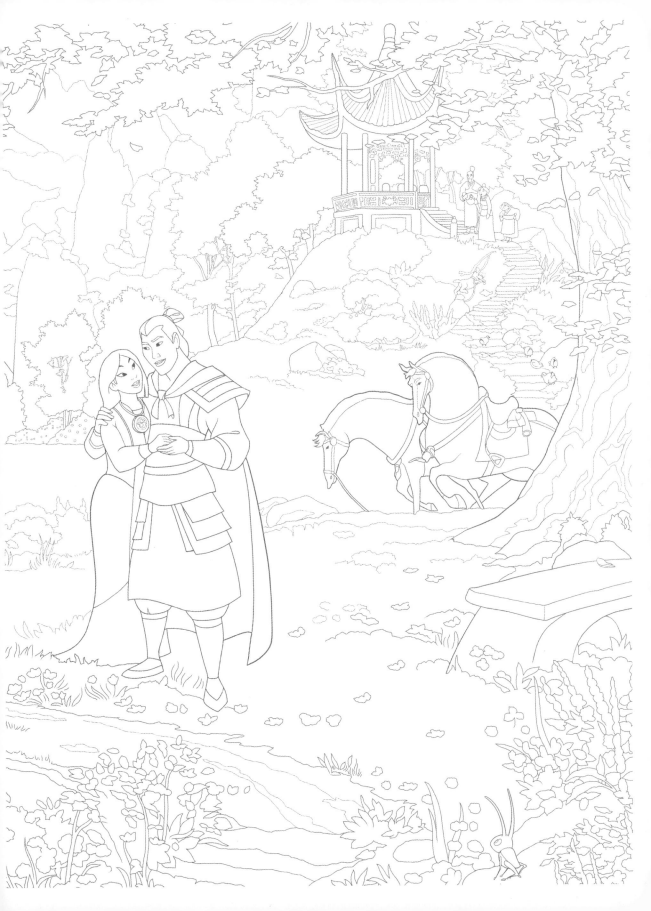

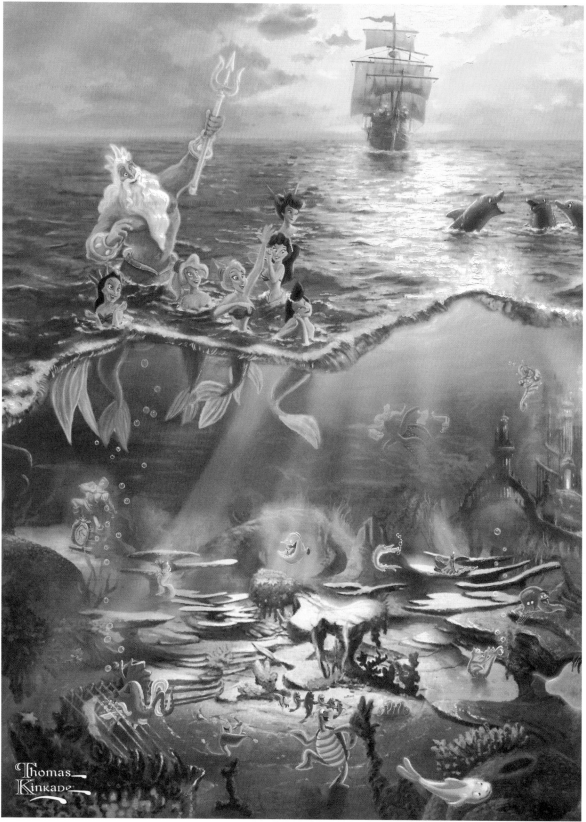

The Little Mermaid

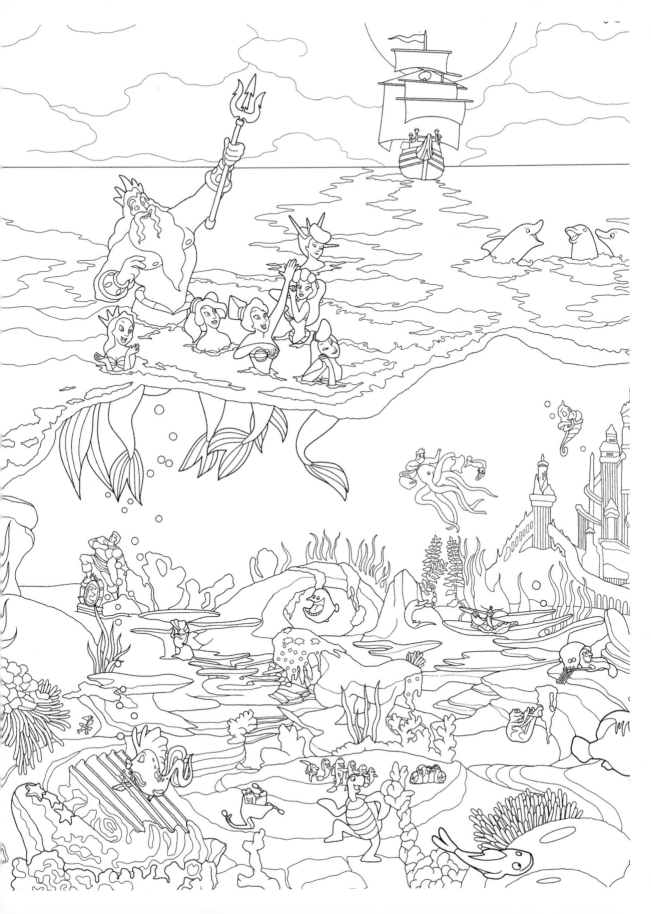

Beauty and the Beast II

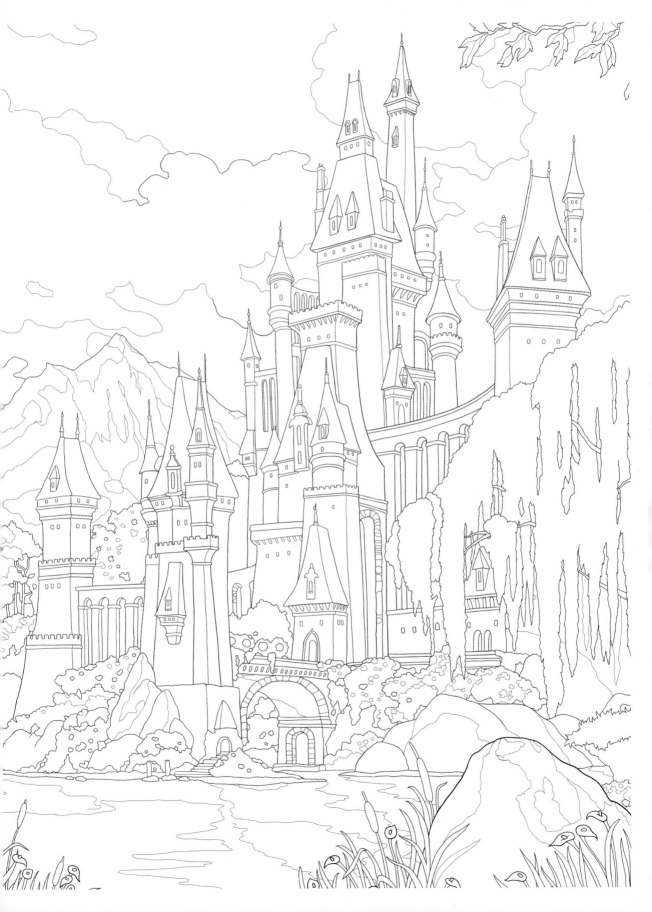

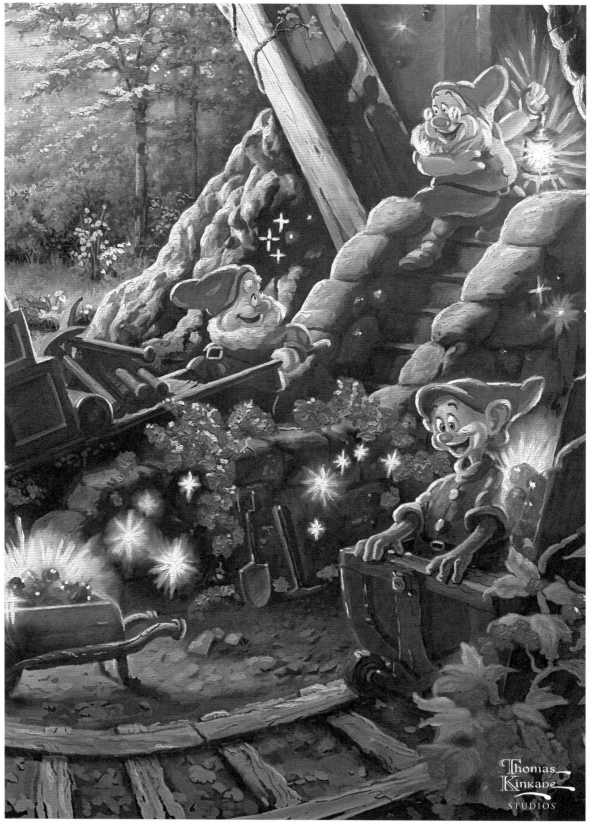

Snow White and the Seven Dwarfs

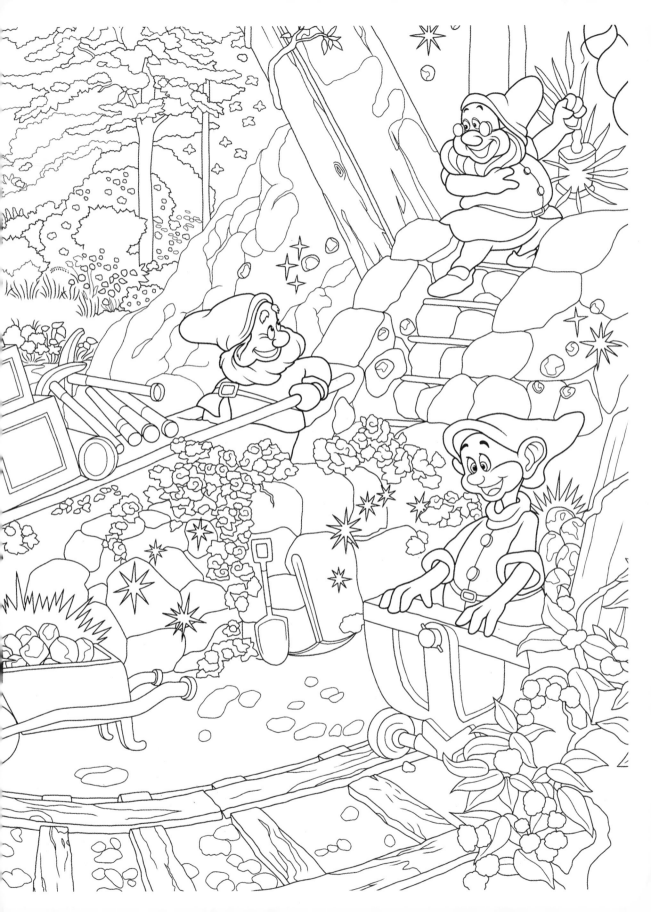

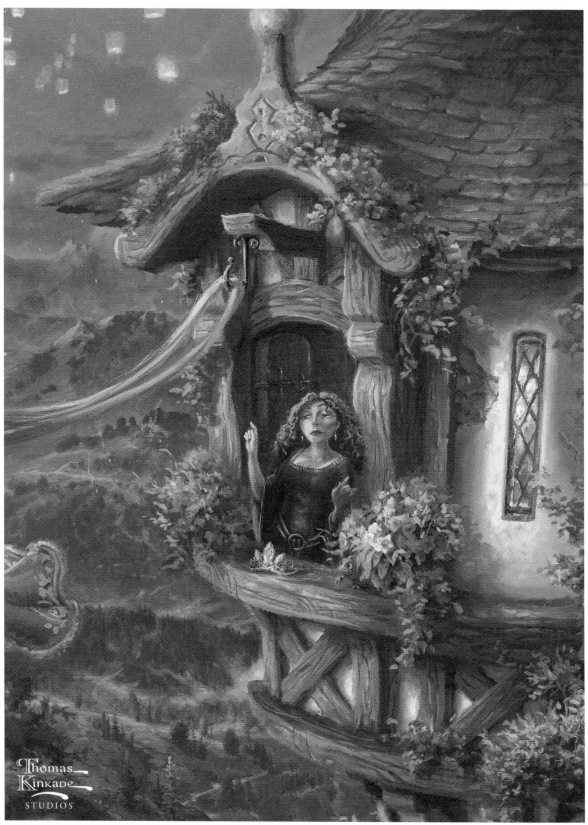

Tangled Up In Love

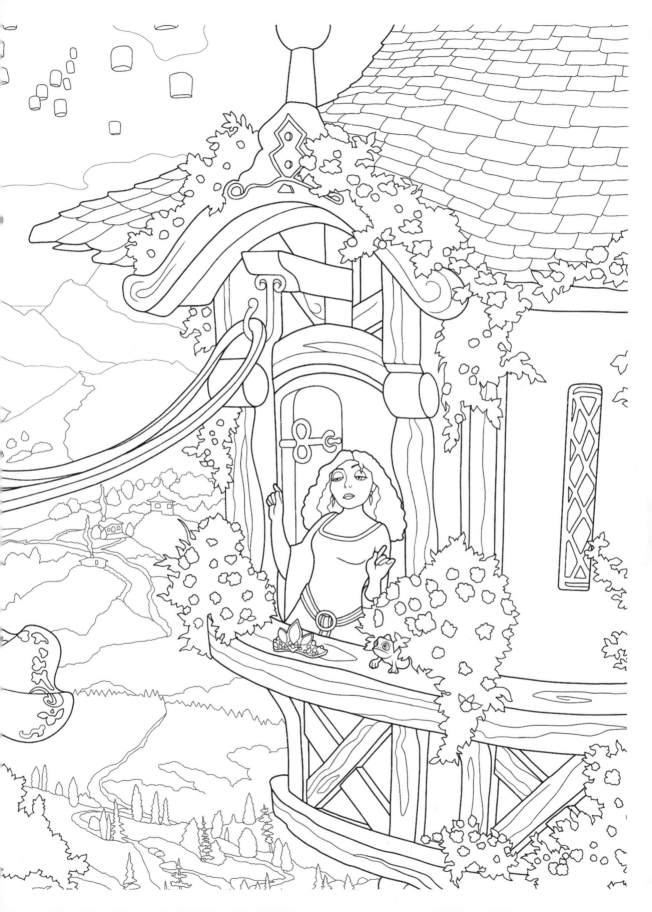

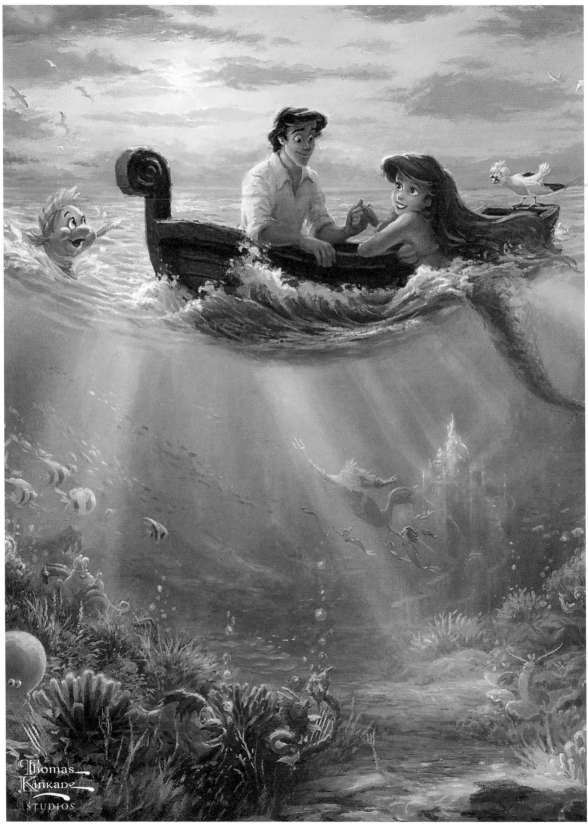

Little Mermaid Falling in Love

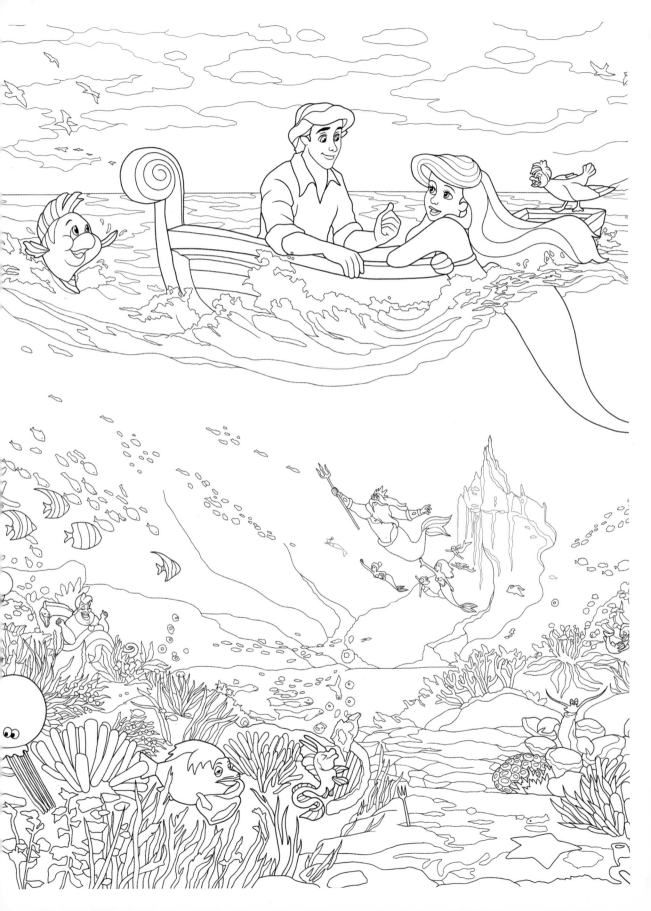

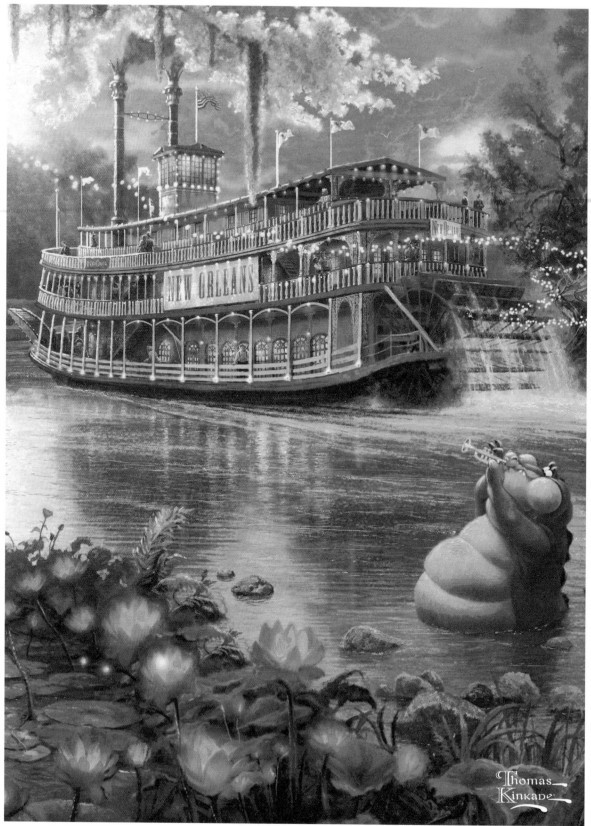

The Princess and the Frog

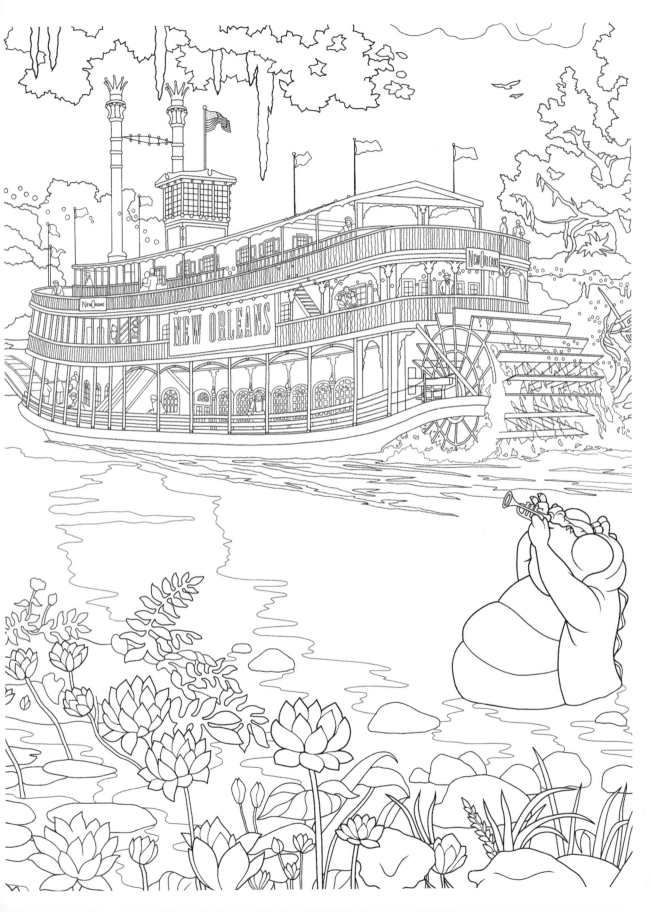

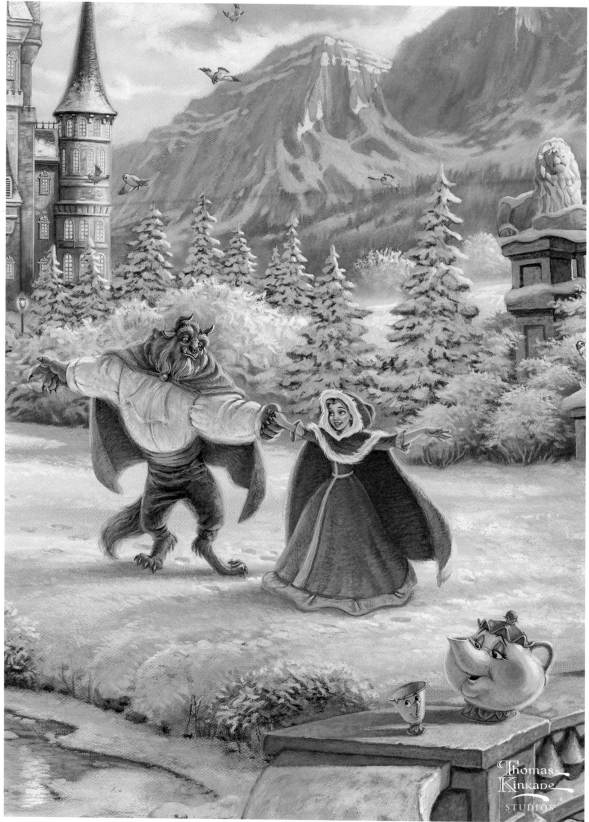

Beauty and the Beast's Winter Enchantment

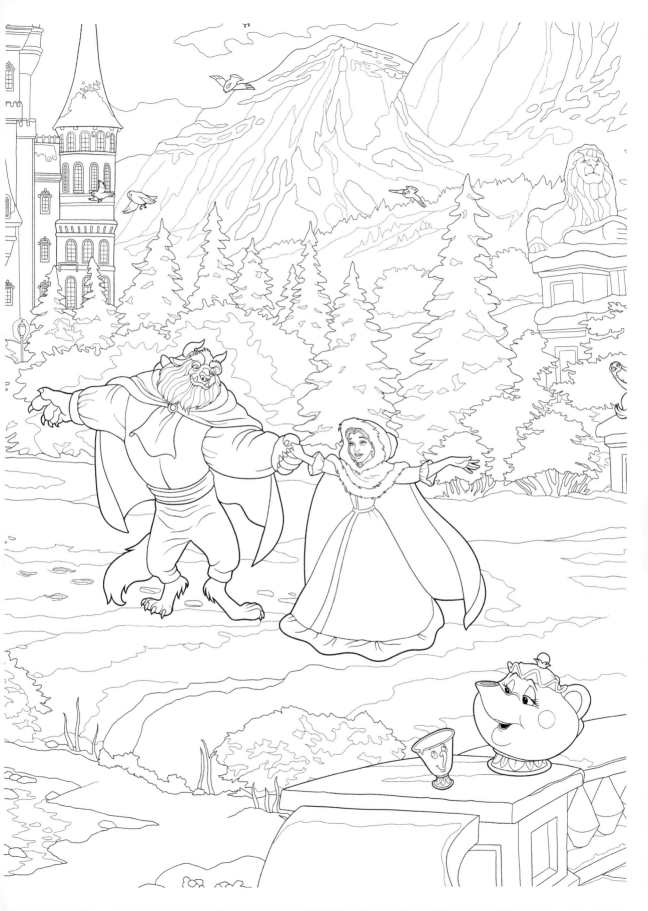

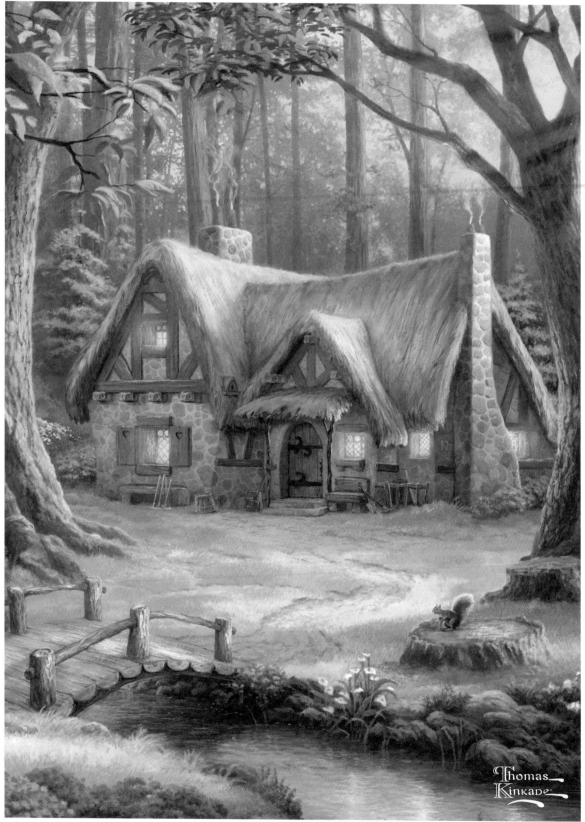

Snow White Discovers the Cottage

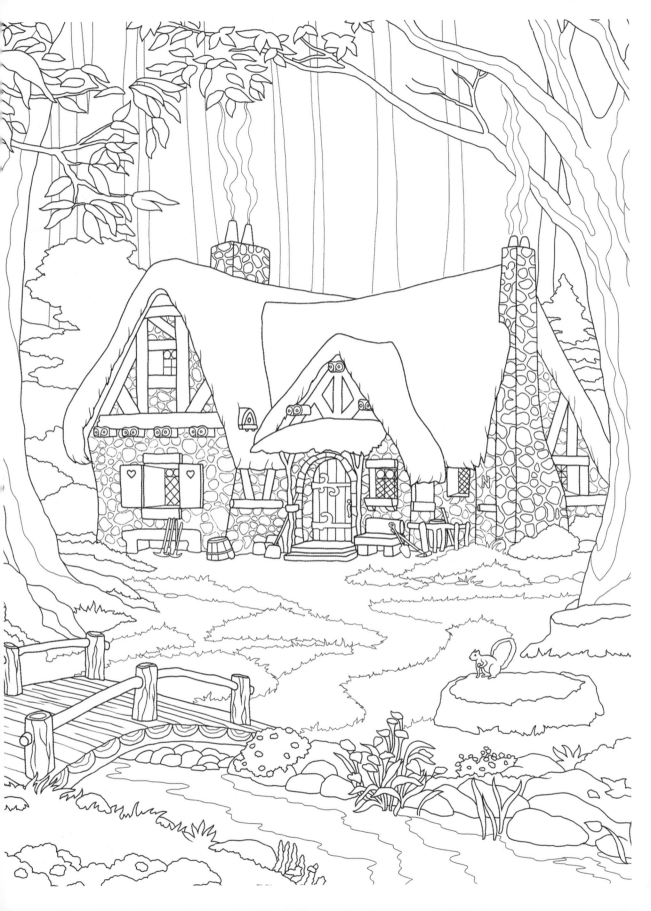

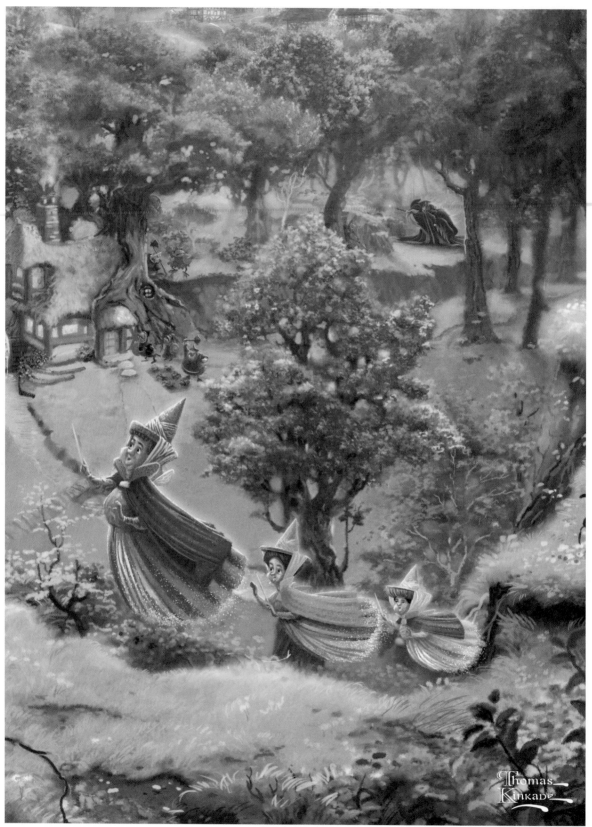

Sleeping Beauty

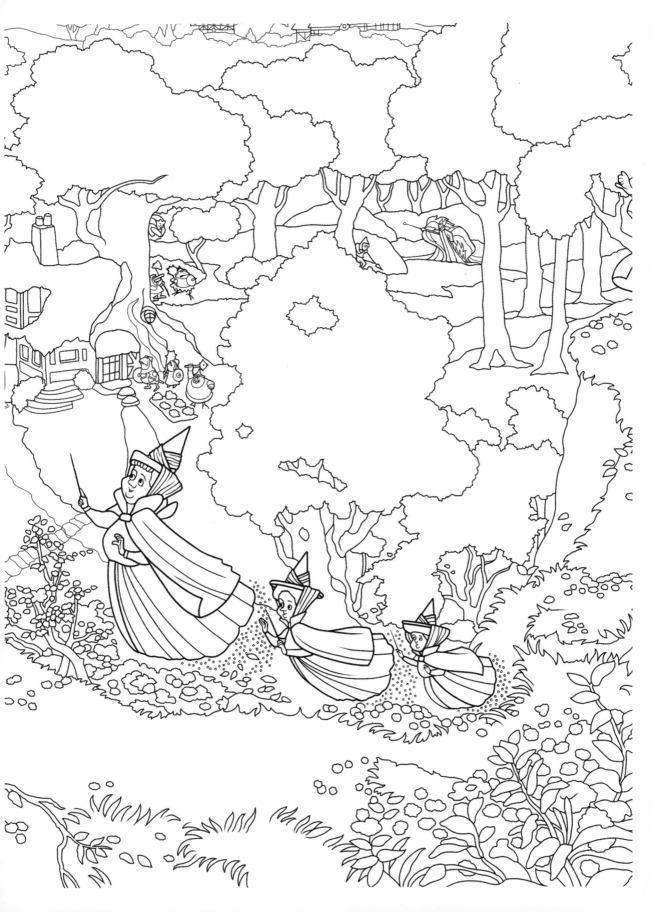

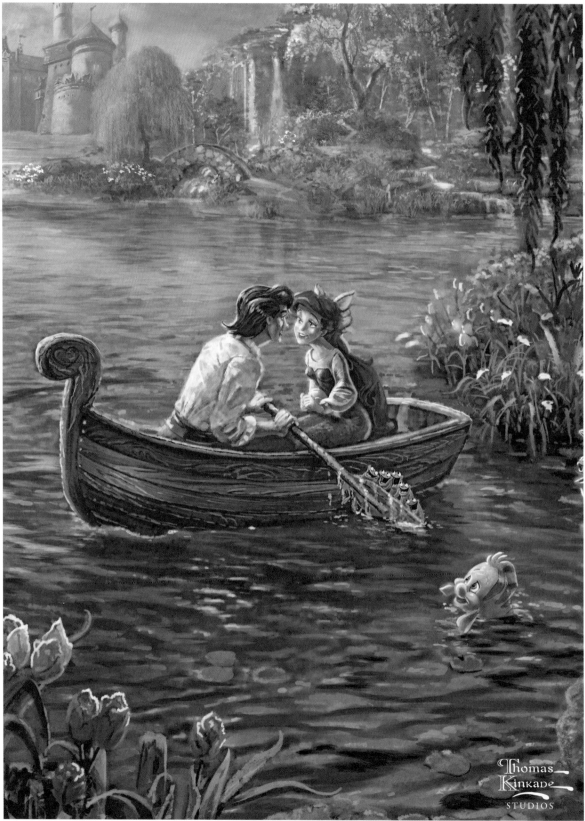

The Little Mermaid II

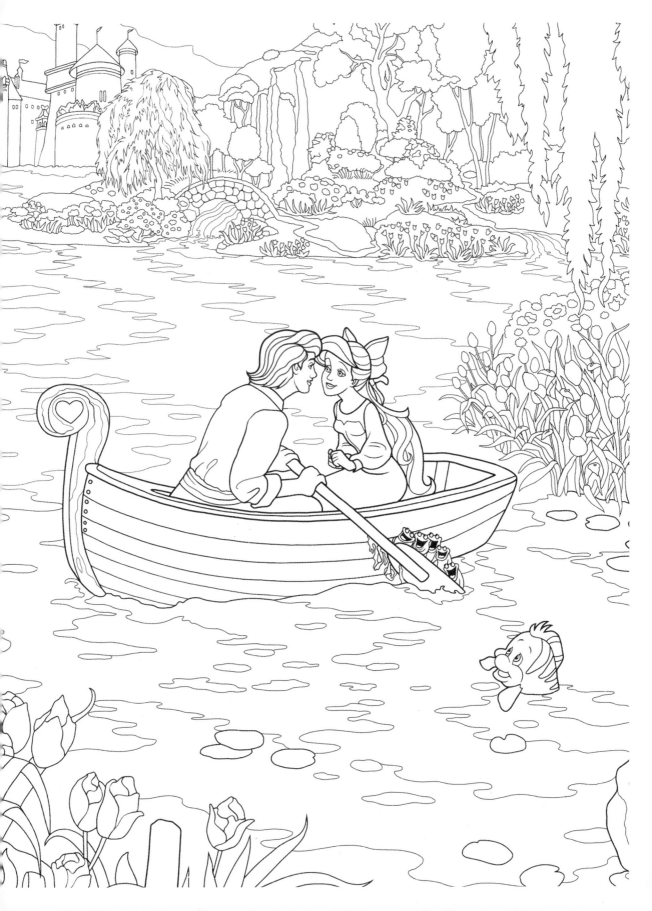

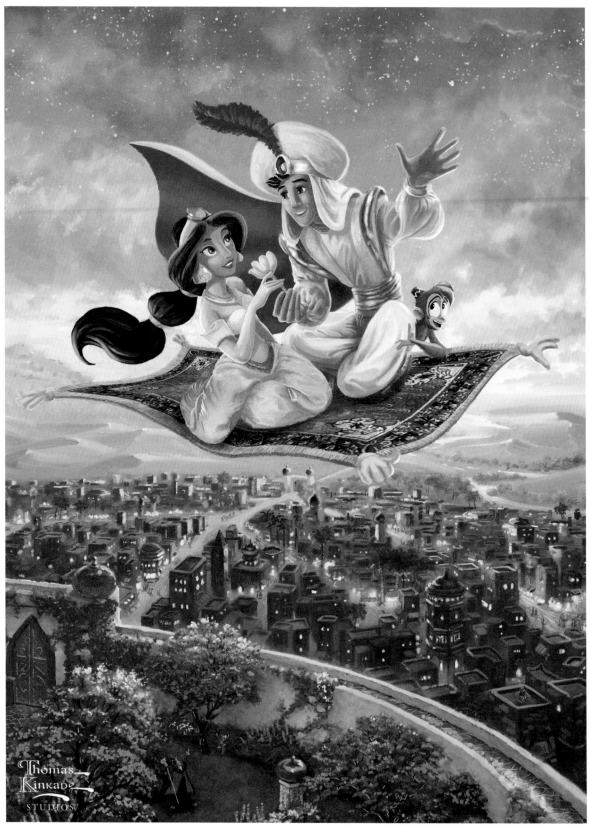

Aladdin

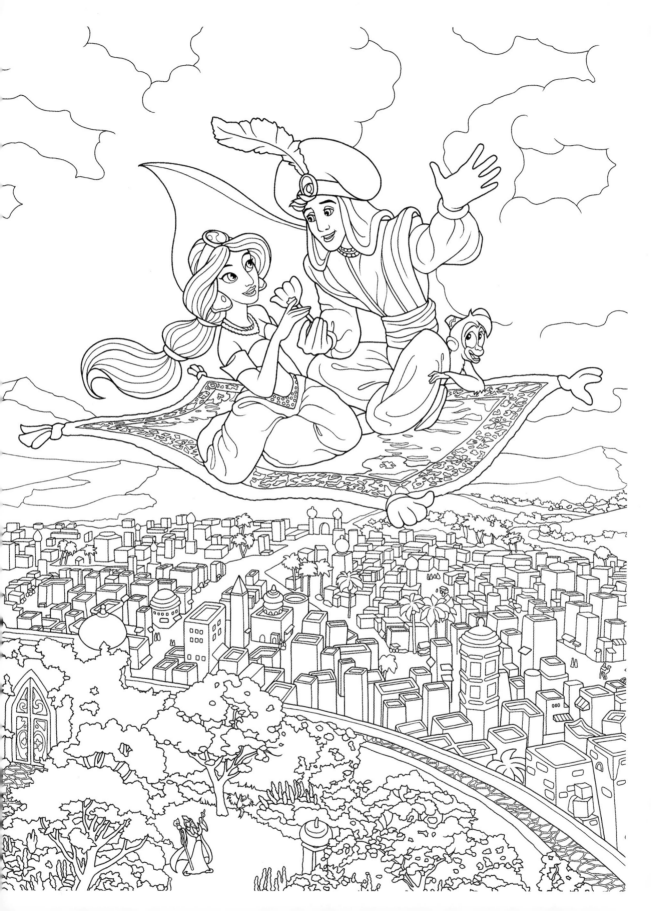

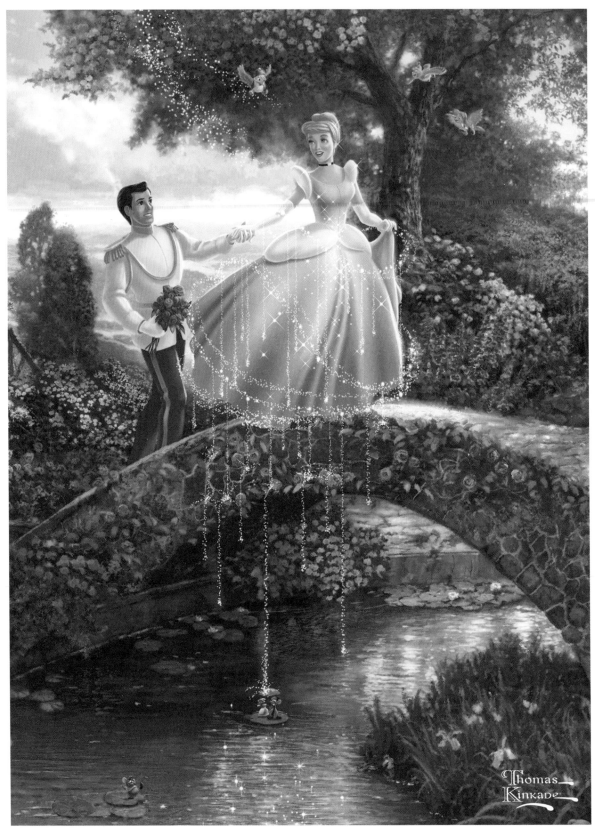

Cinderella Wishes Upon a Dream

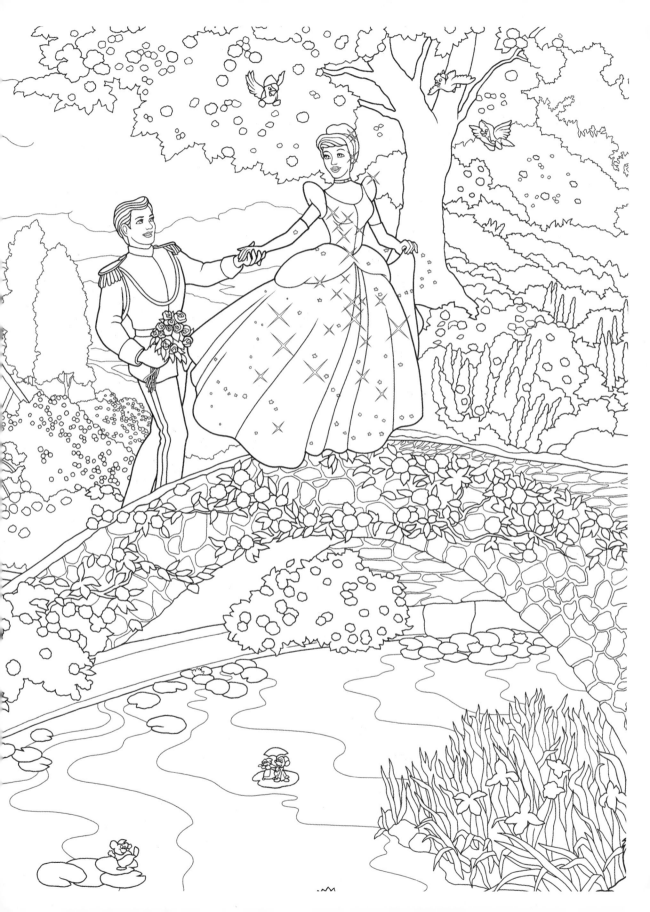

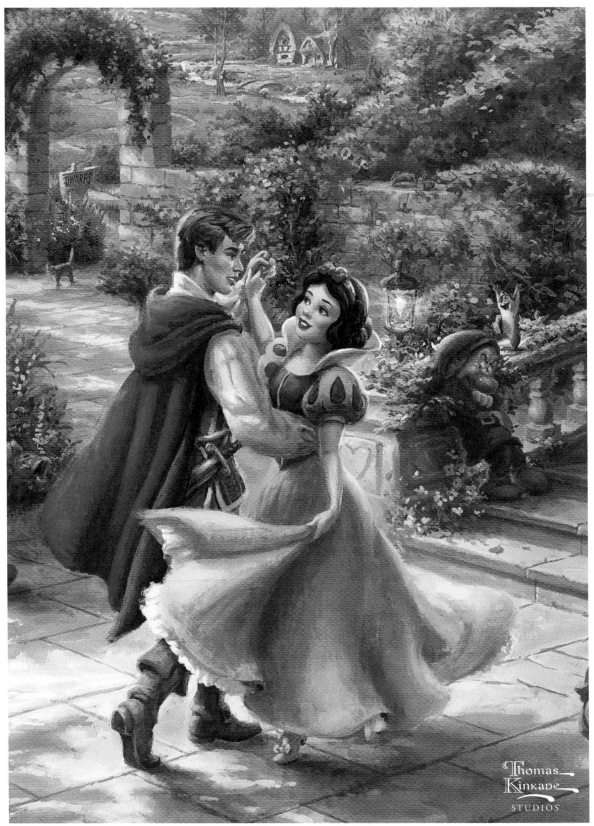

Snow White Dancing in the Sunlight

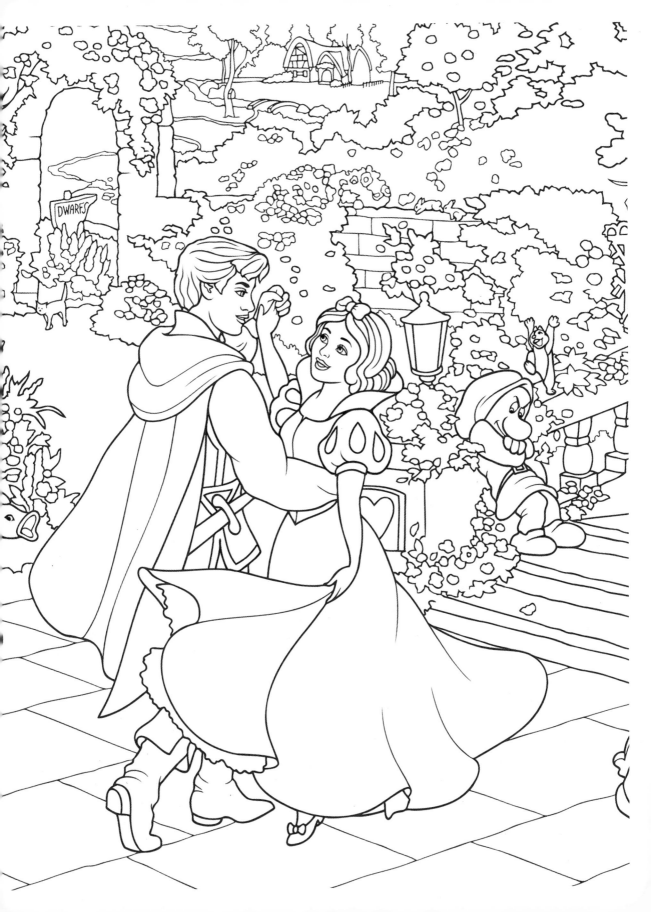

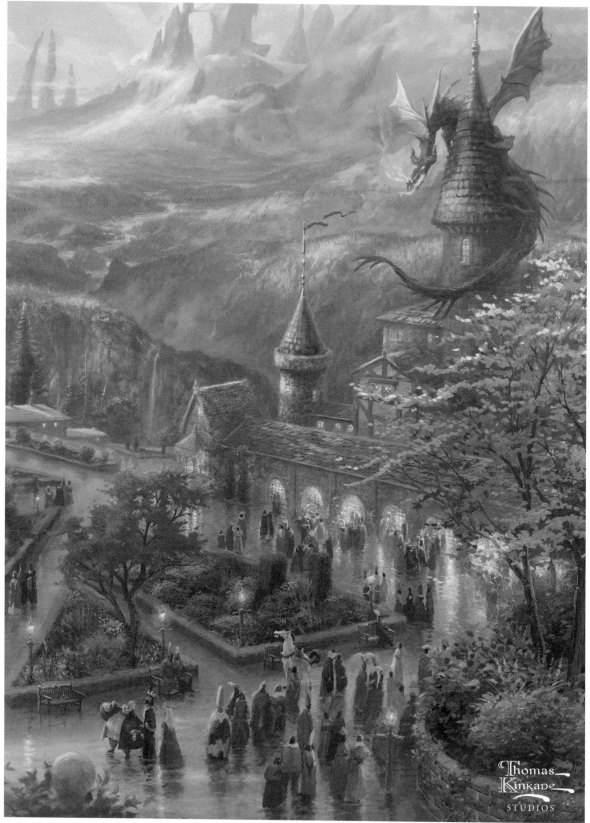

Sleeping Beauty Dancing in the Enchanted Light

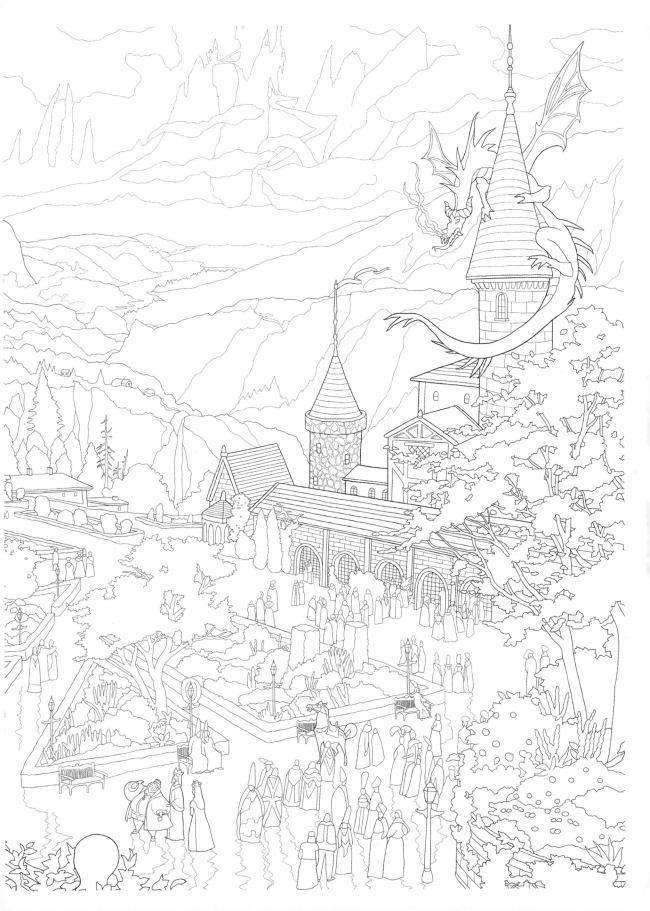

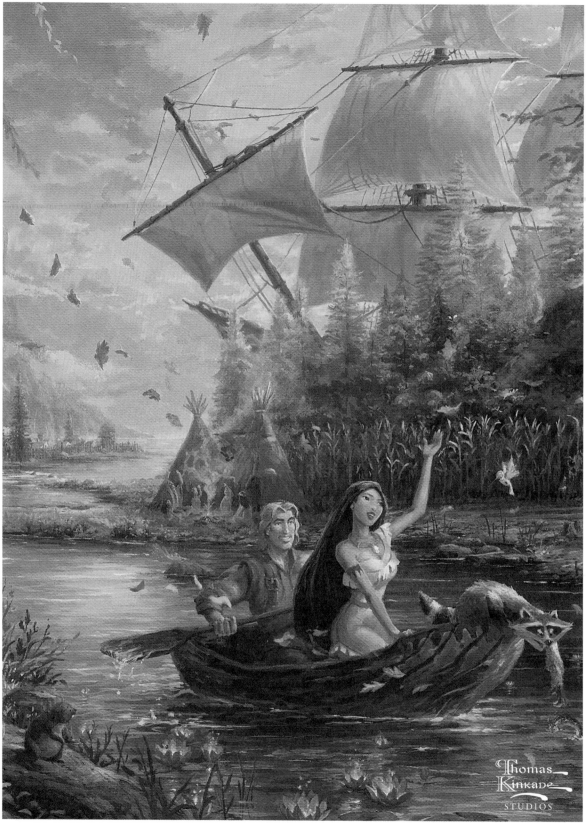

Pocahontas

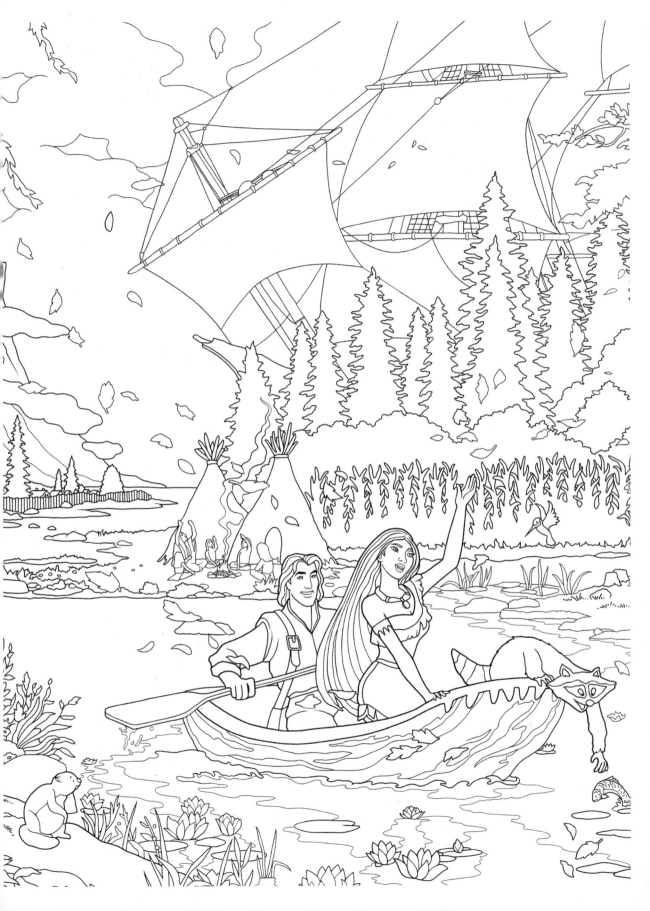

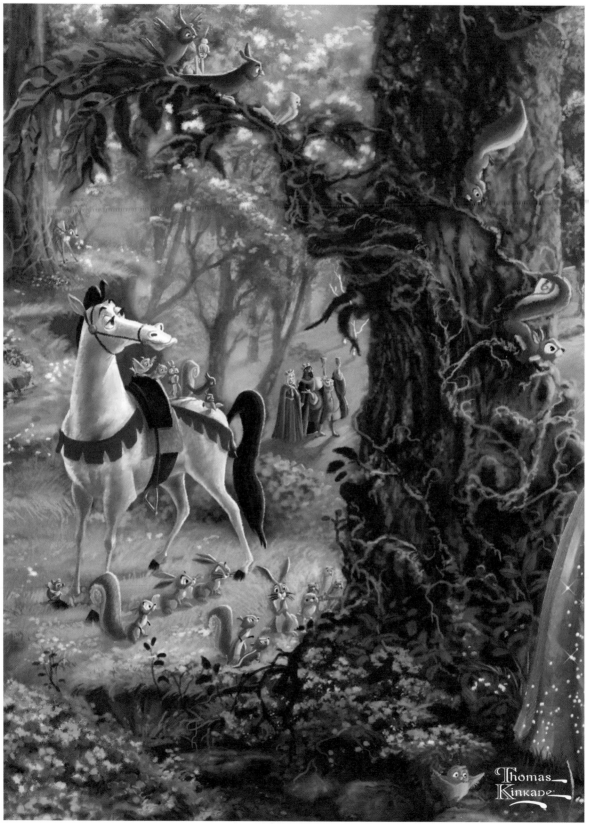

Sleeping Beauty

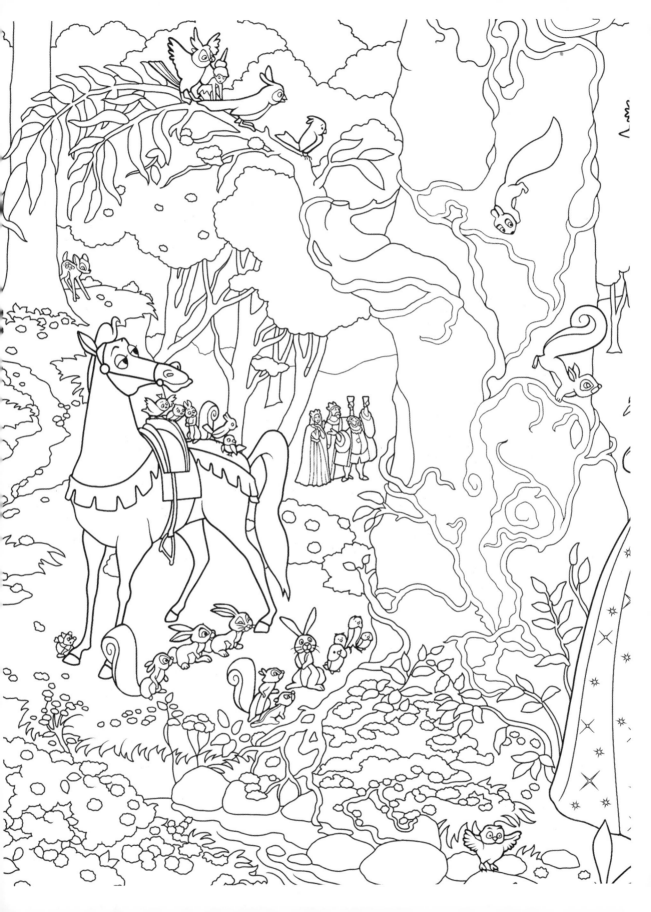

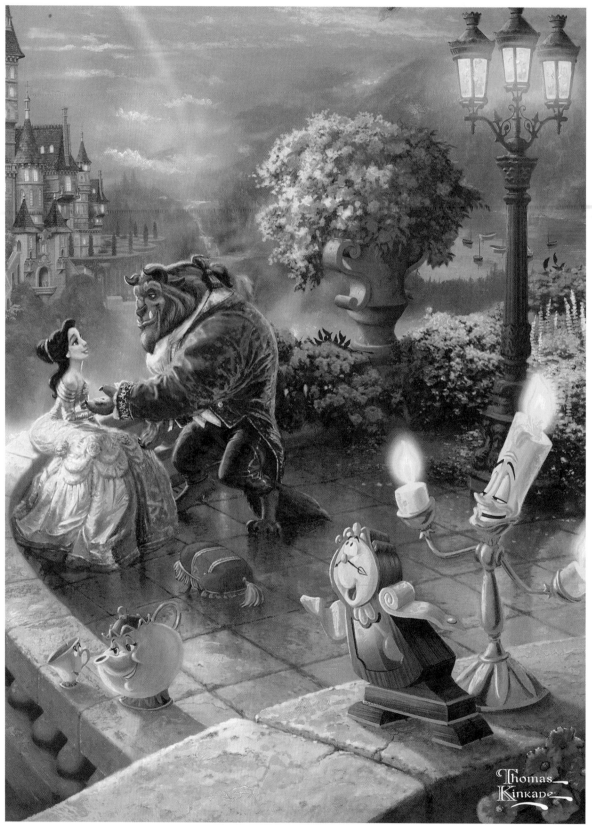

Beauty and the Beast Falling in Love

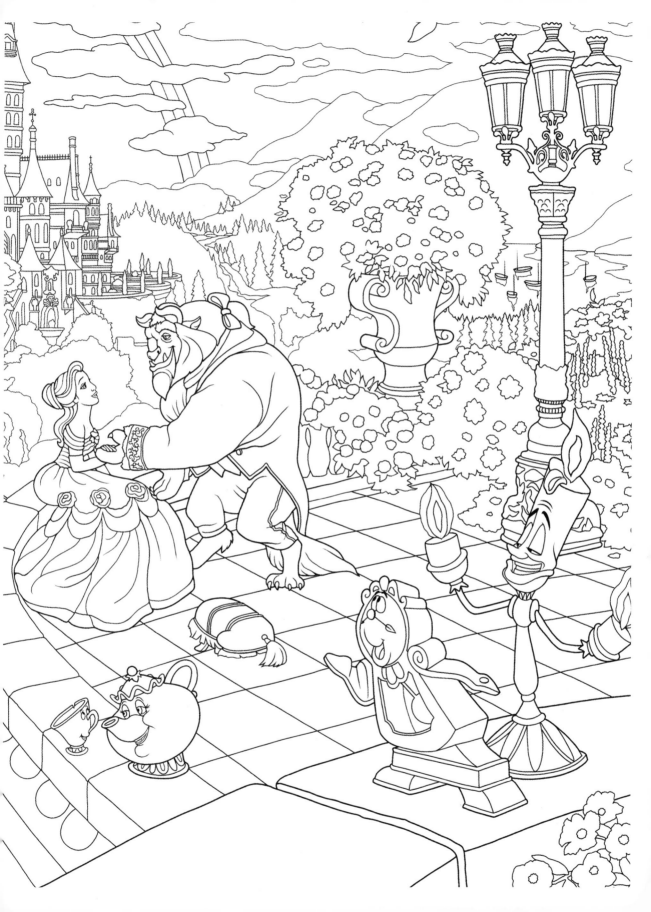

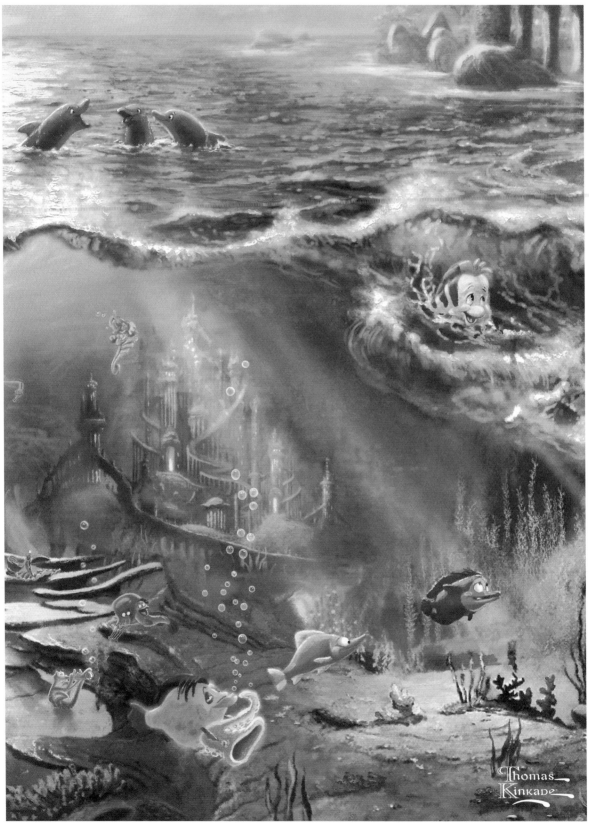

The Little Mermaid

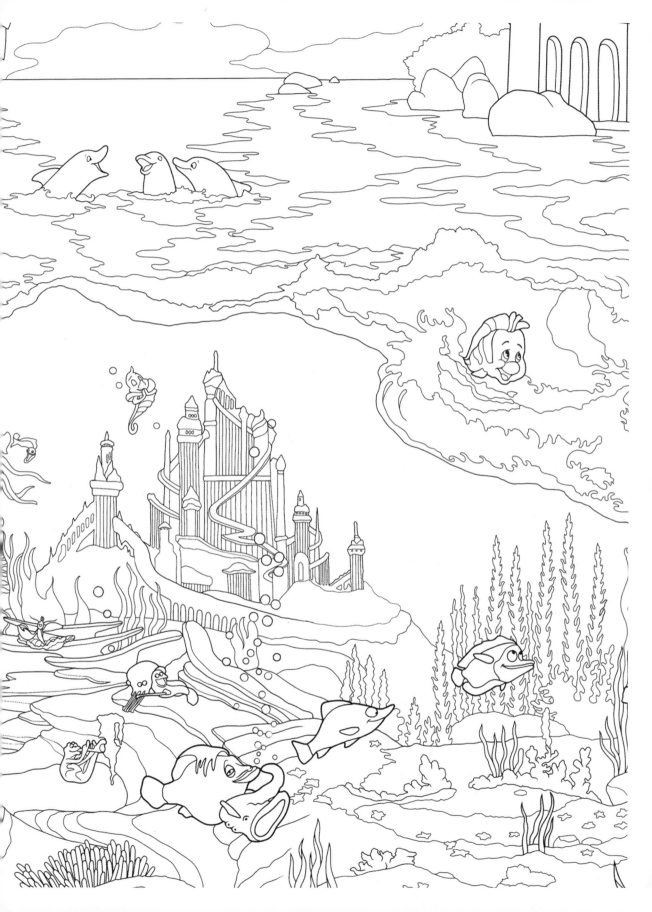

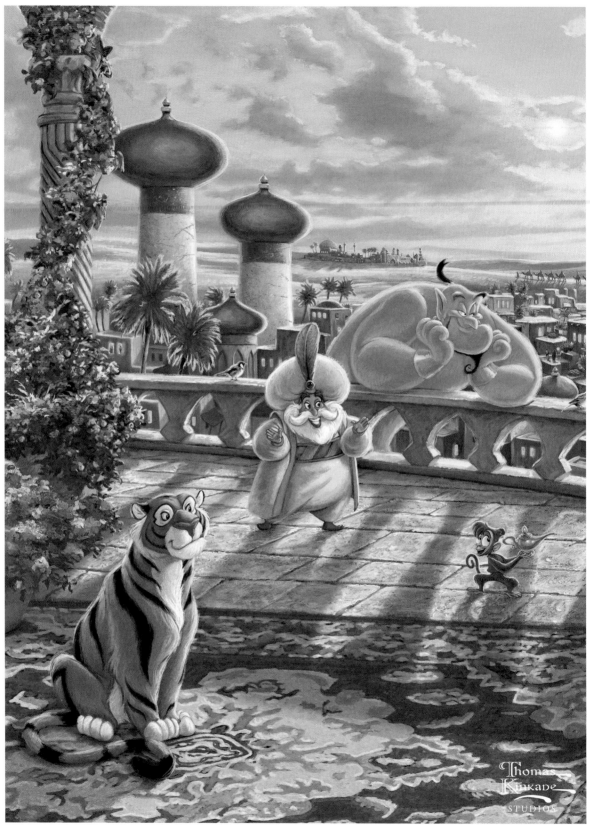

Jasmine Dancing in the Desert Sunset

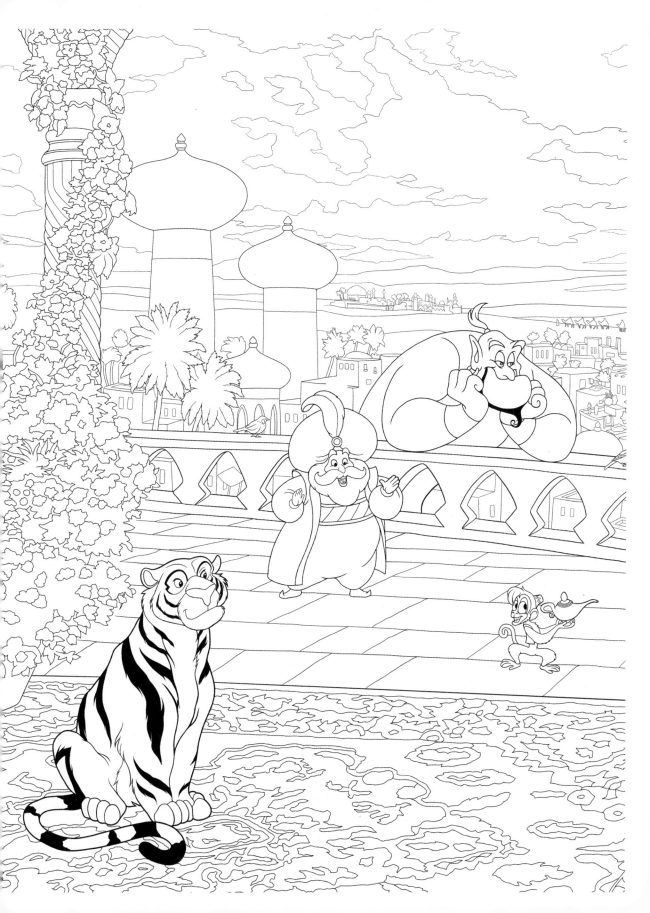

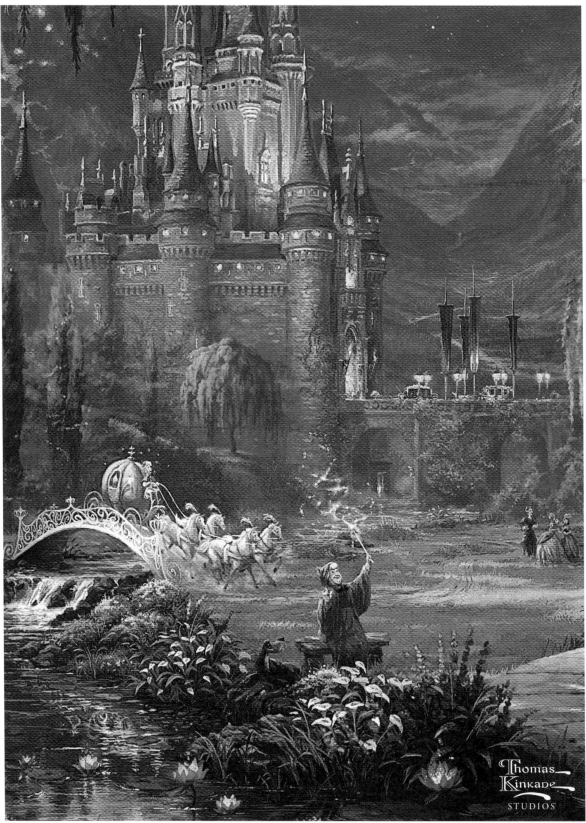

Cinderella Dancing in the Starlight

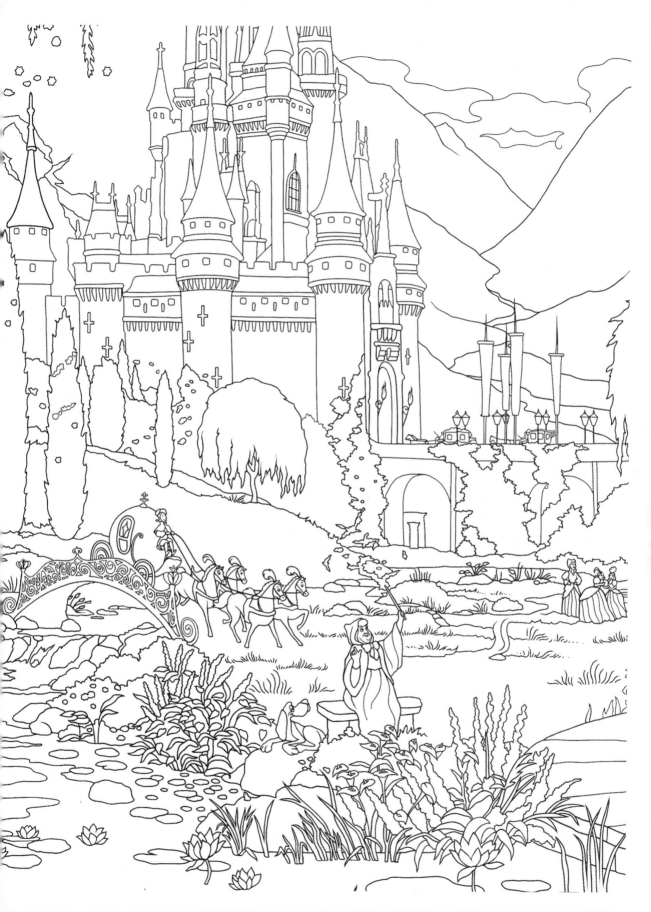

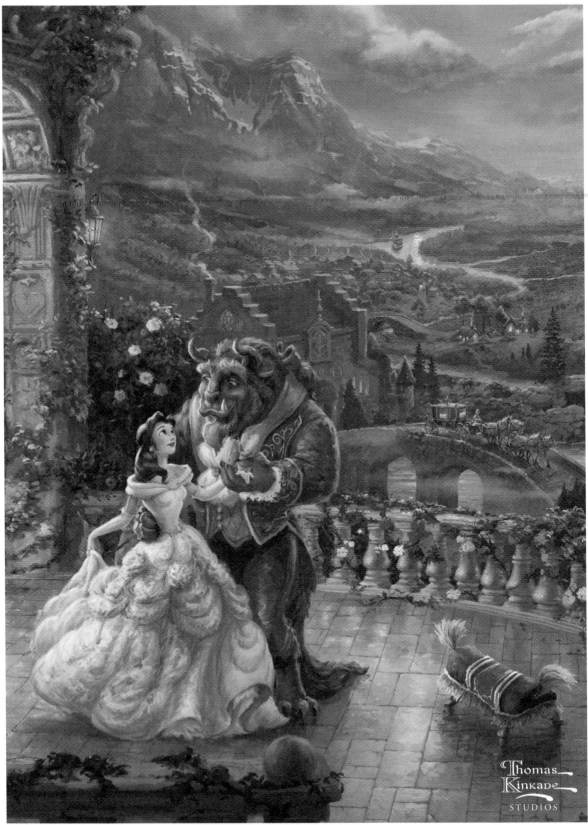

Beauty and the Beast Dancing in the Moonlight

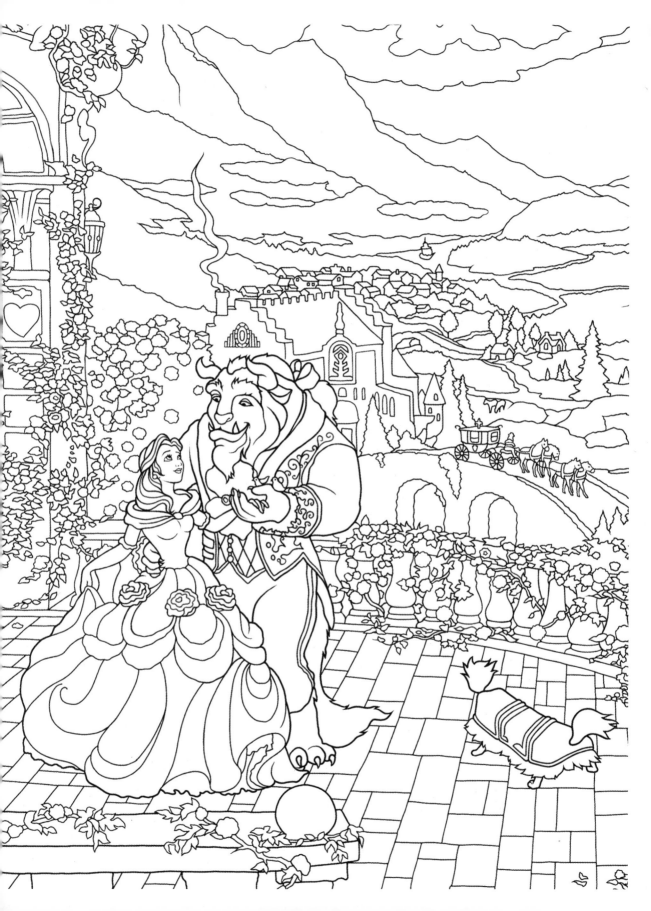

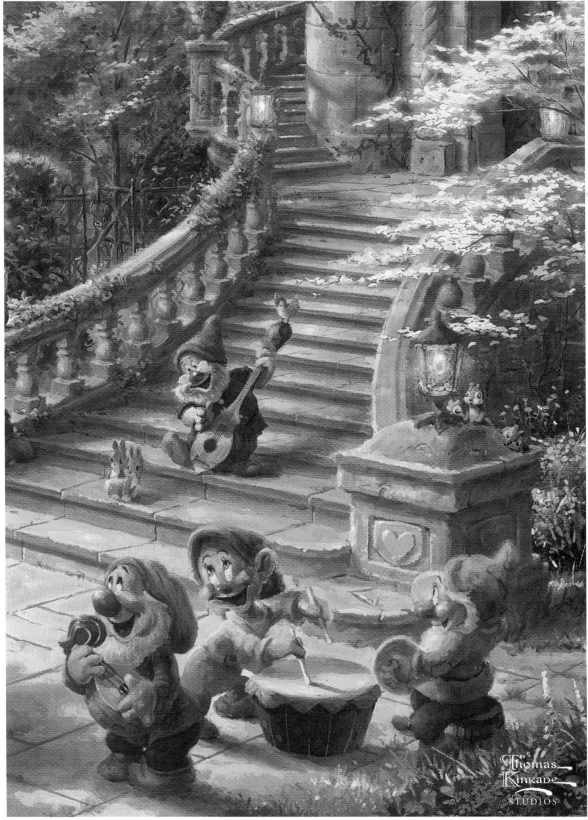

Snow White Dancing in the Sunlight

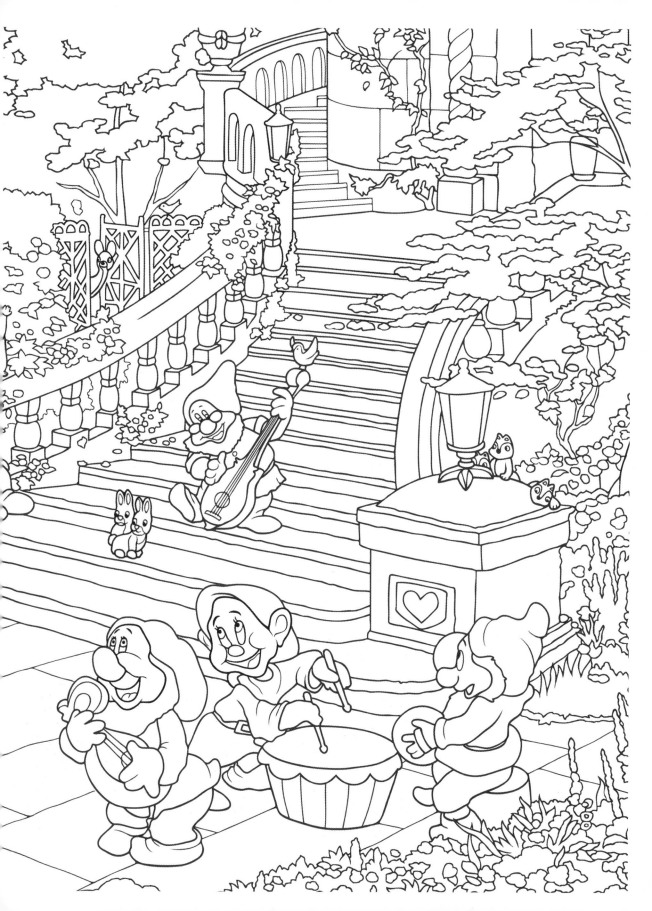

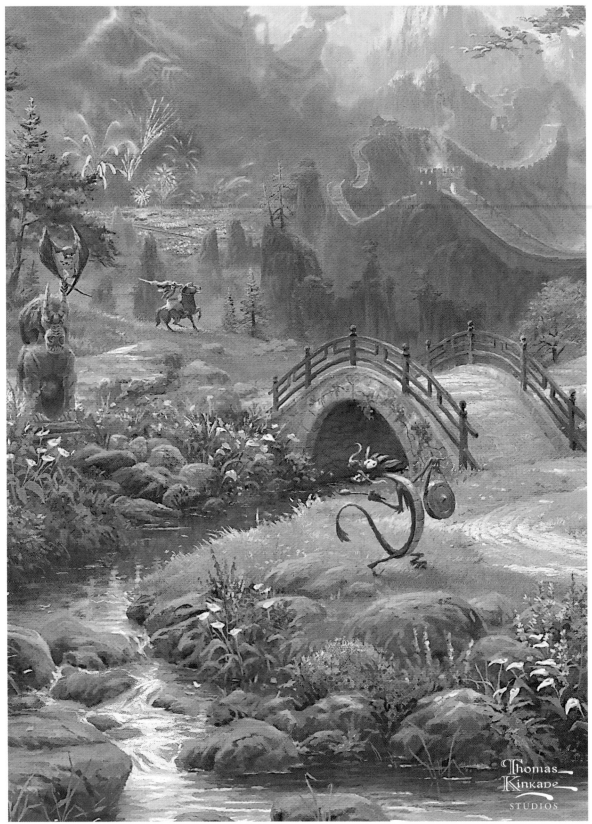

Mulan Blossoms of Love

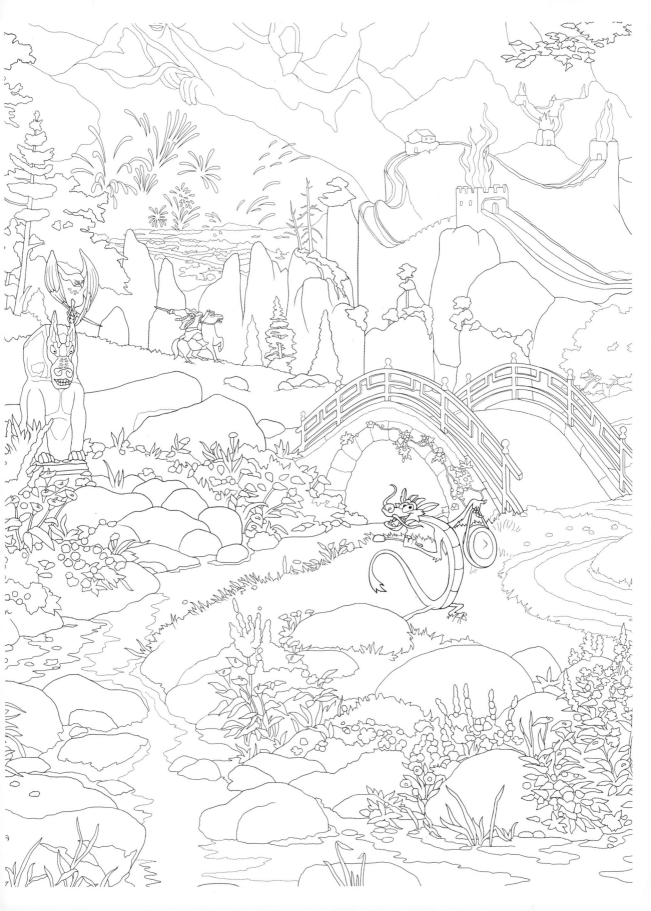

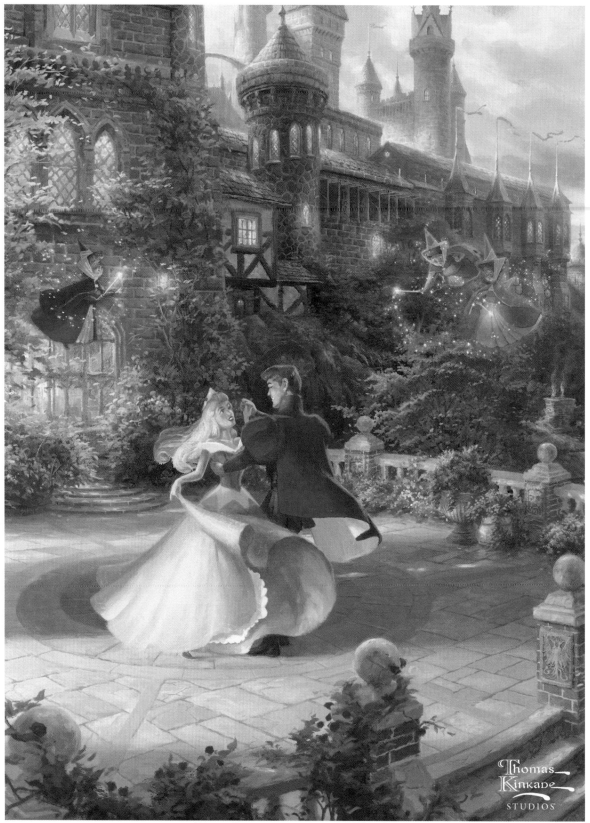

Sleeping Beauty Dancing in the Enchanted Light

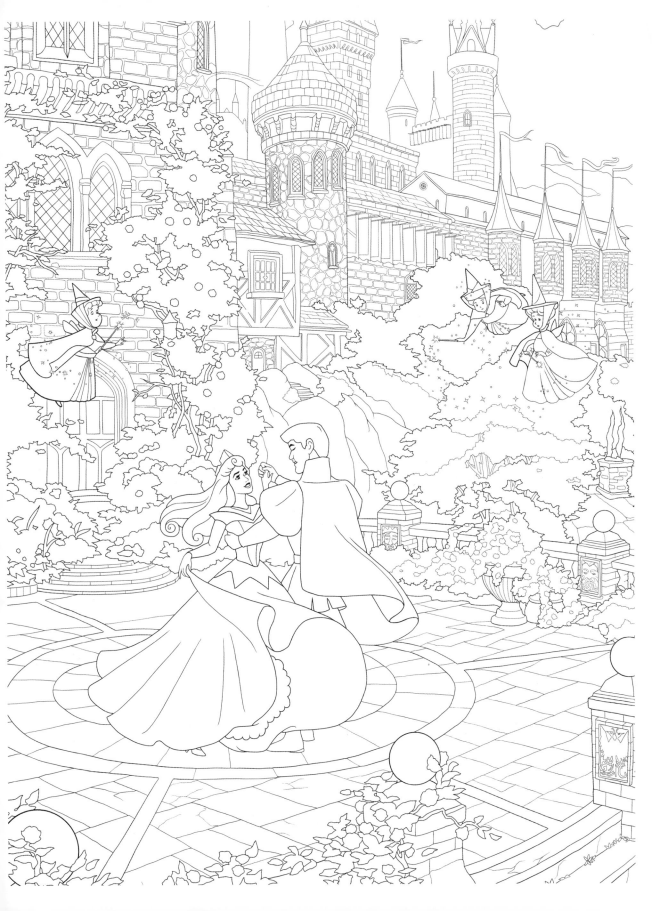

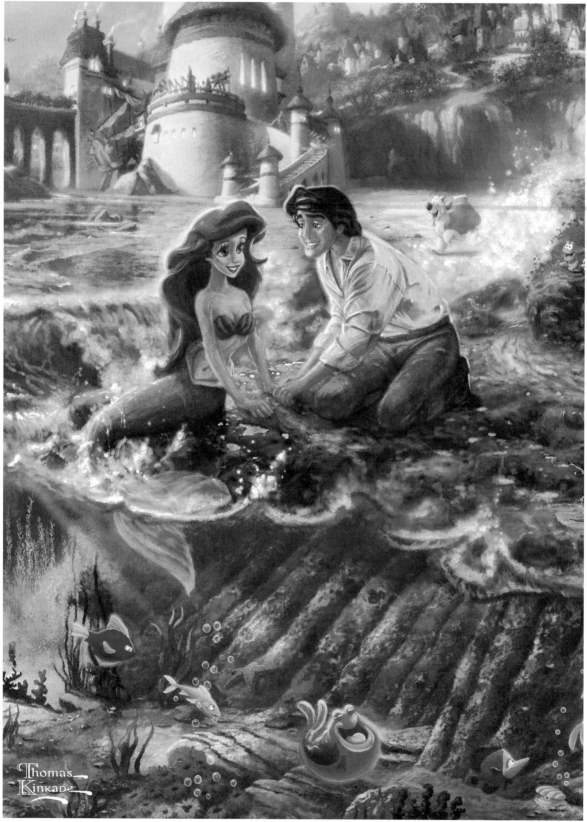

The Little Mermaid

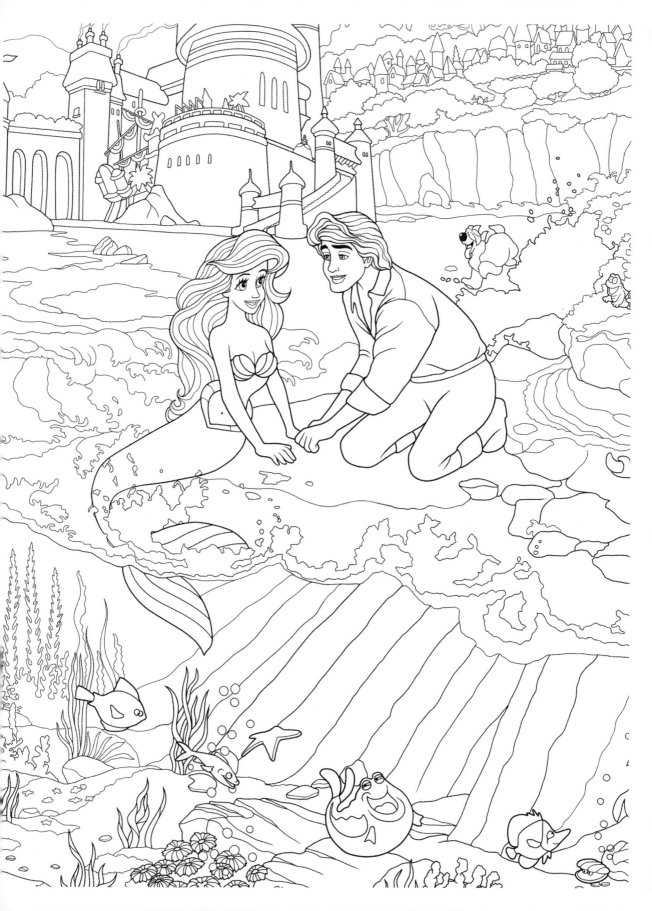

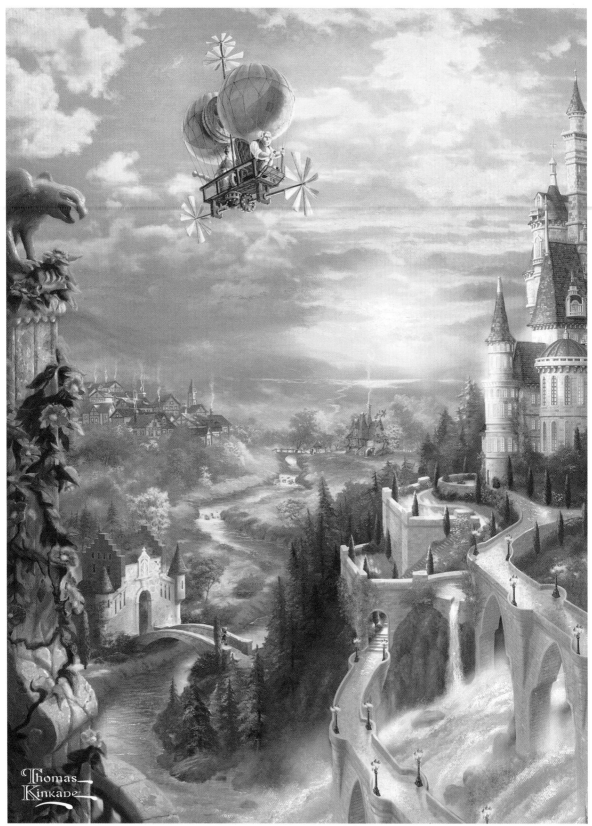

Beauty and the Beast Falling in Love

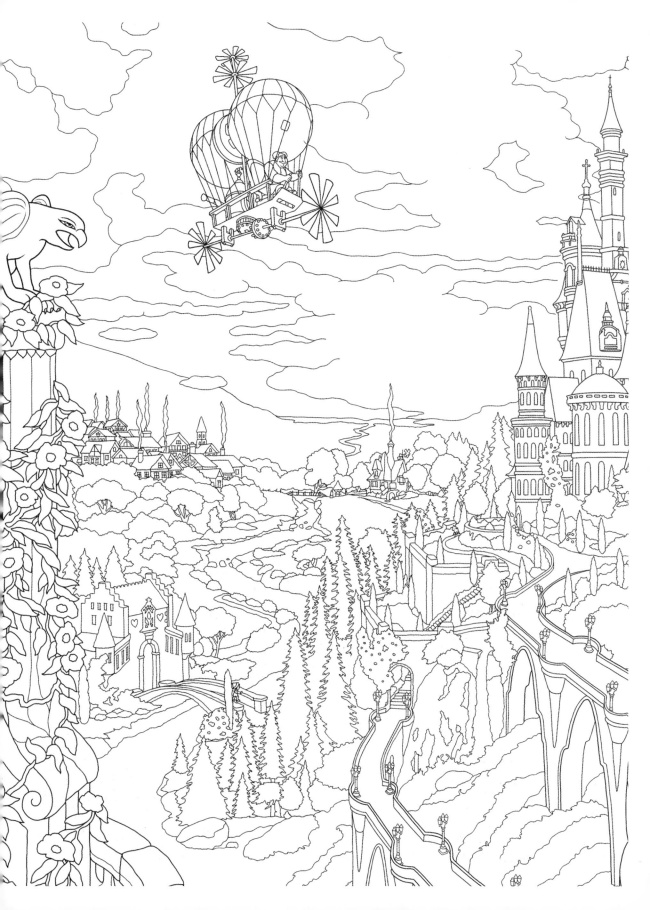

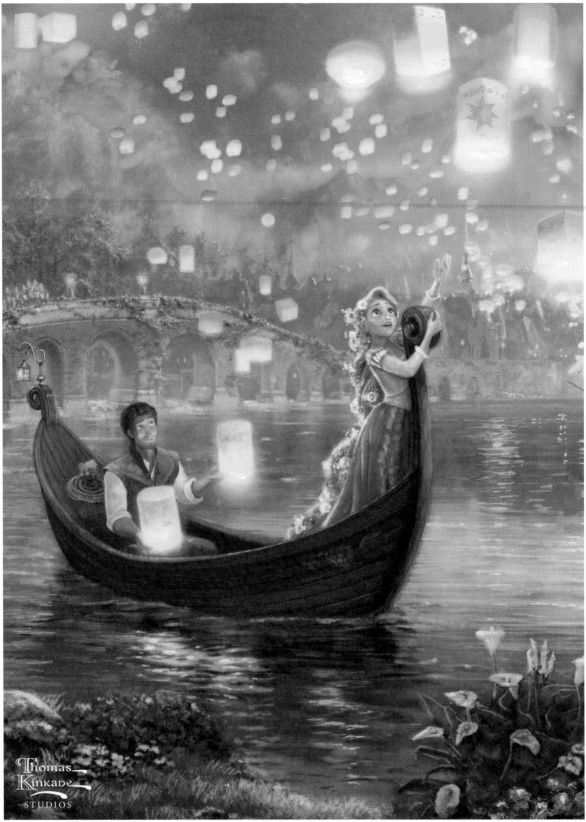

Tangled

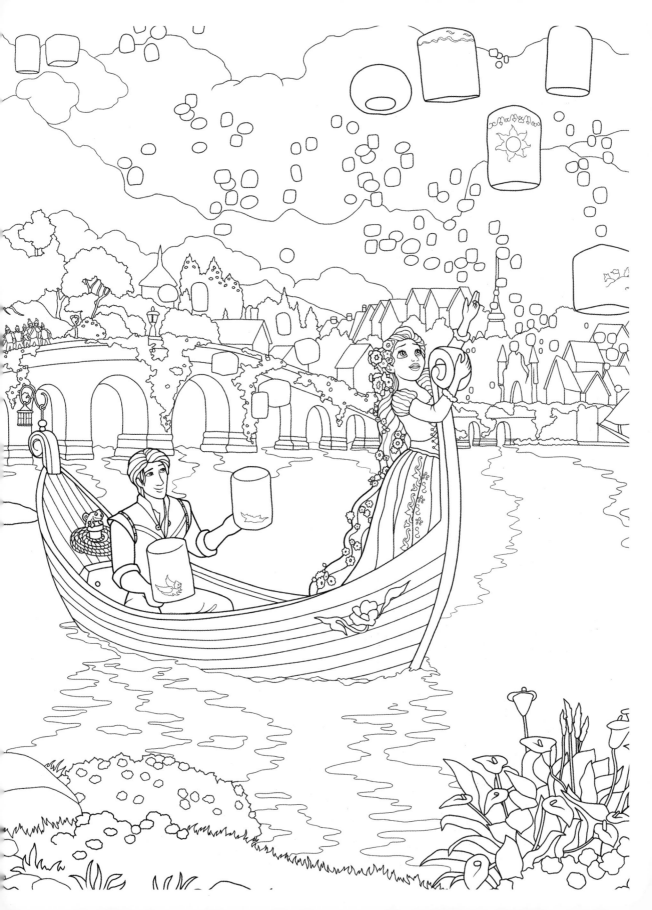

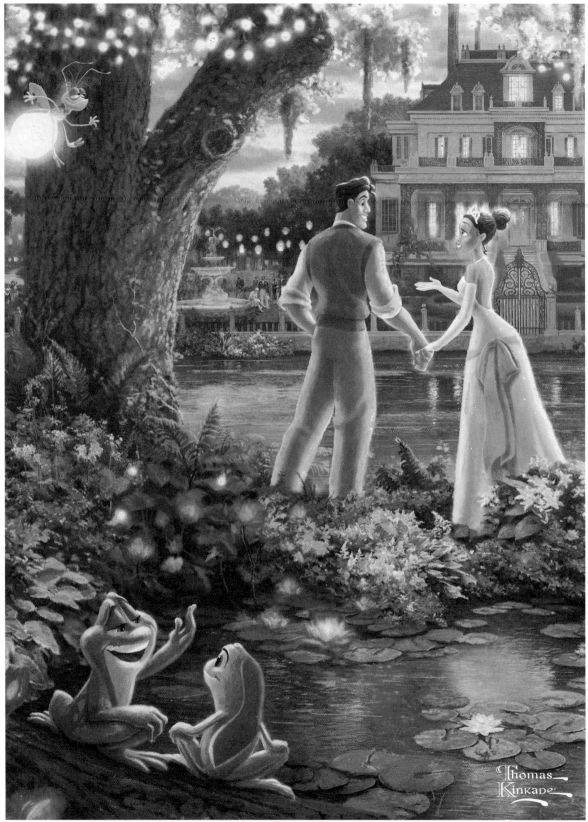

The Princess and the Frog

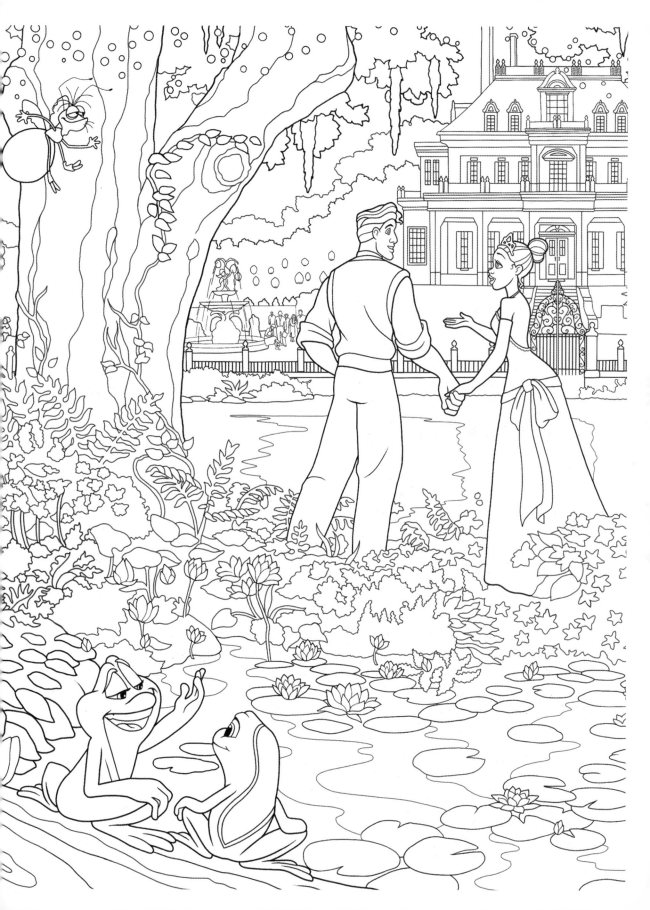

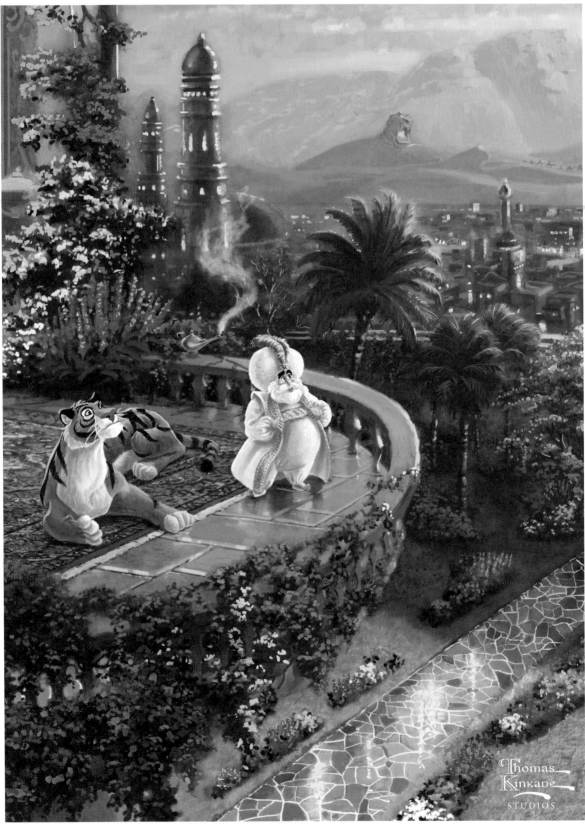

Aladdin

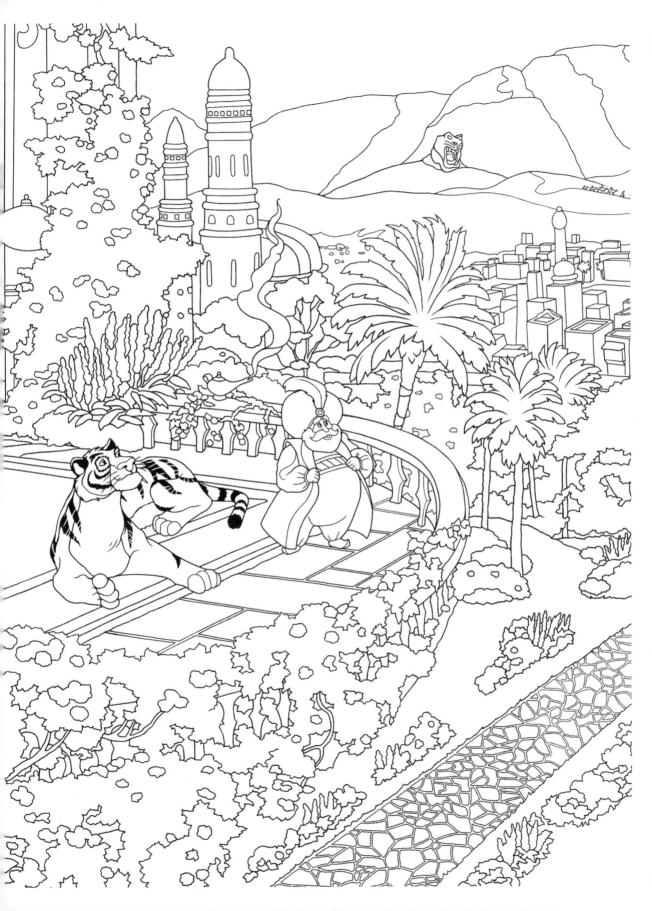

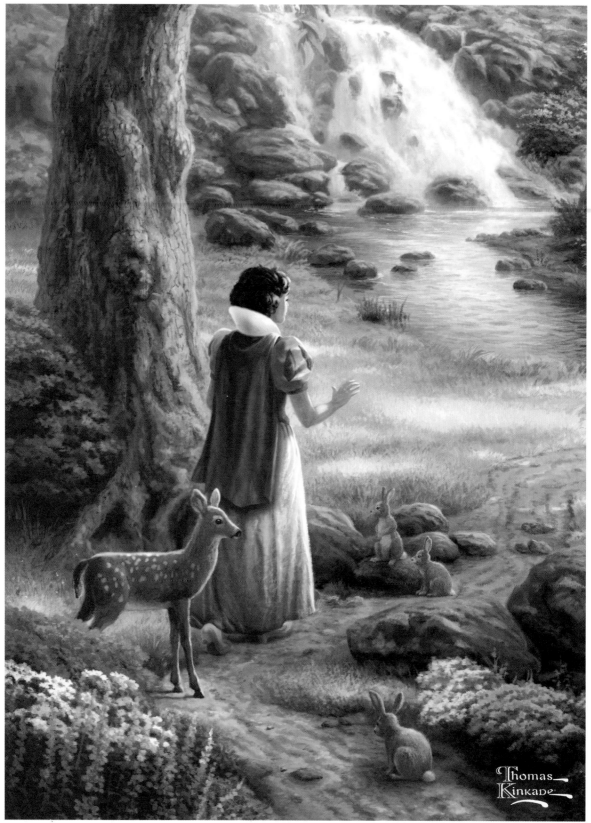

Snow White Discovers the Cottage

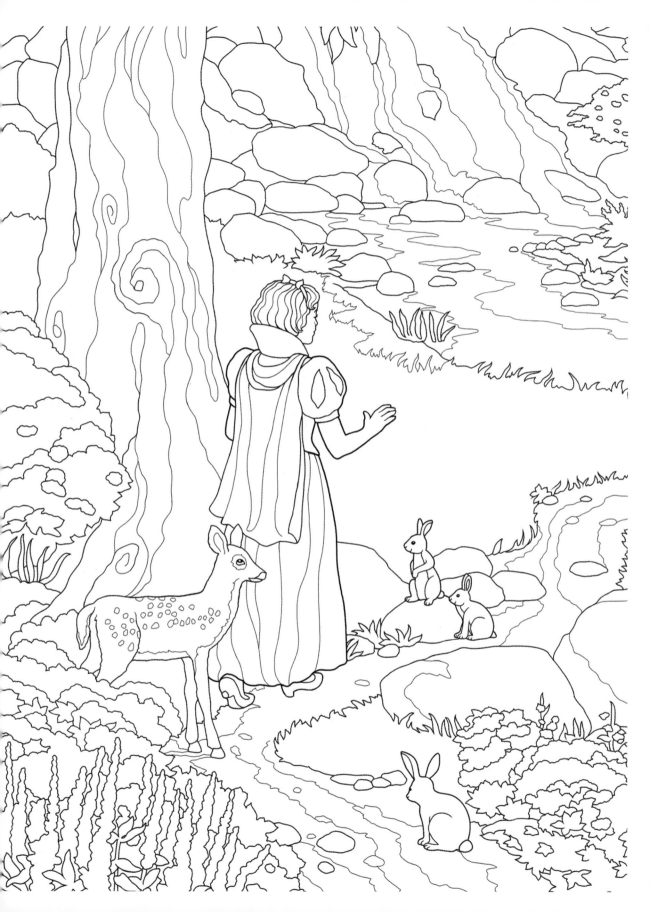

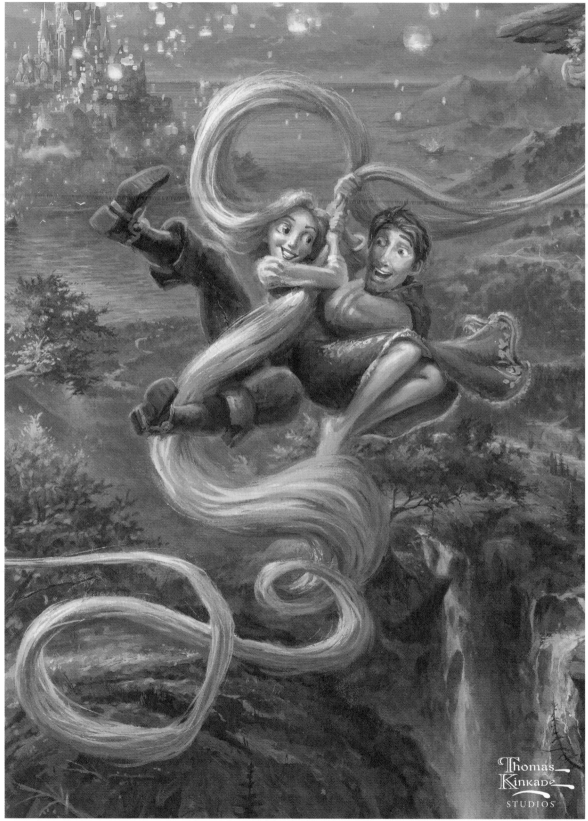

Tangled Up In Love

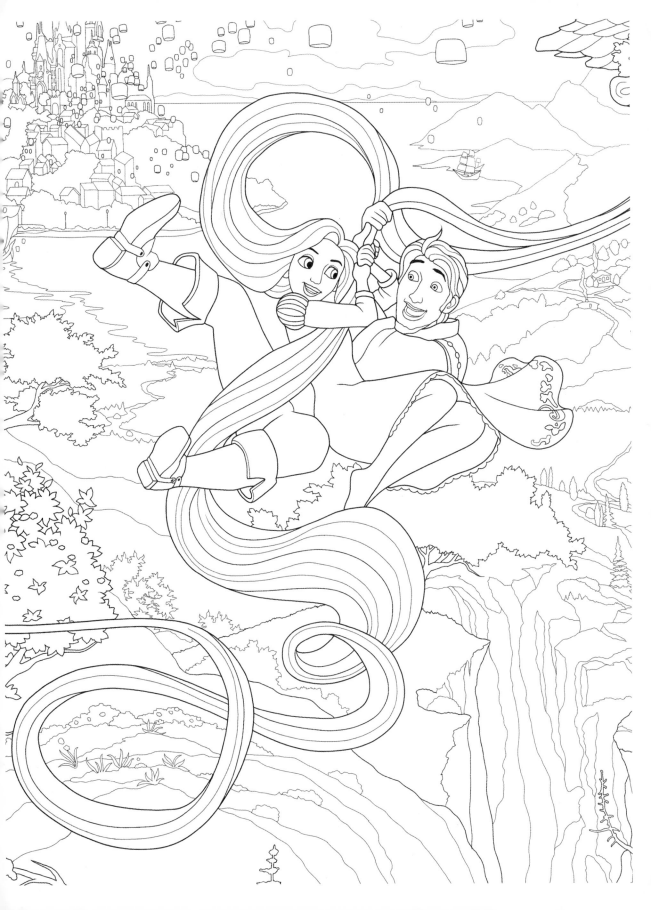

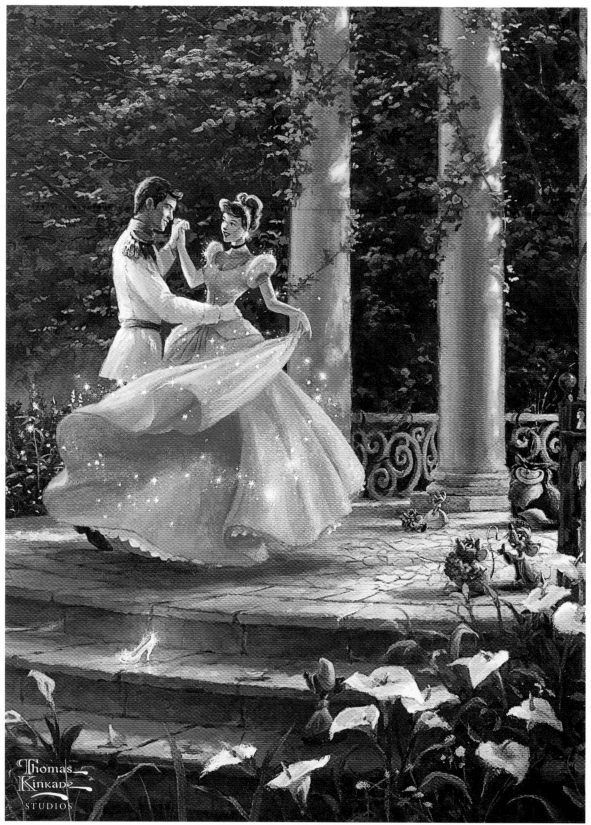

Cinderella Dancing in the Starlight

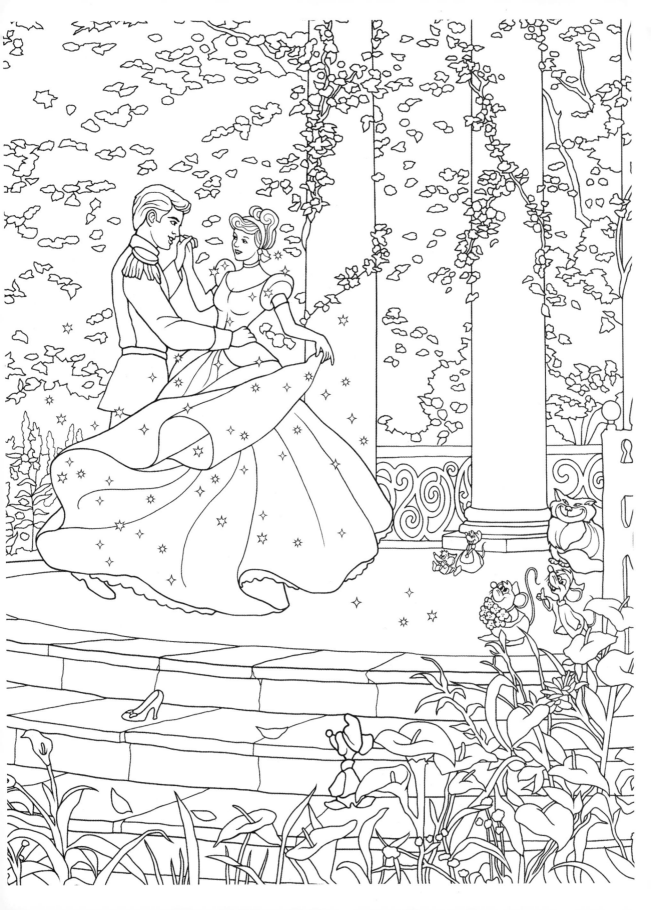

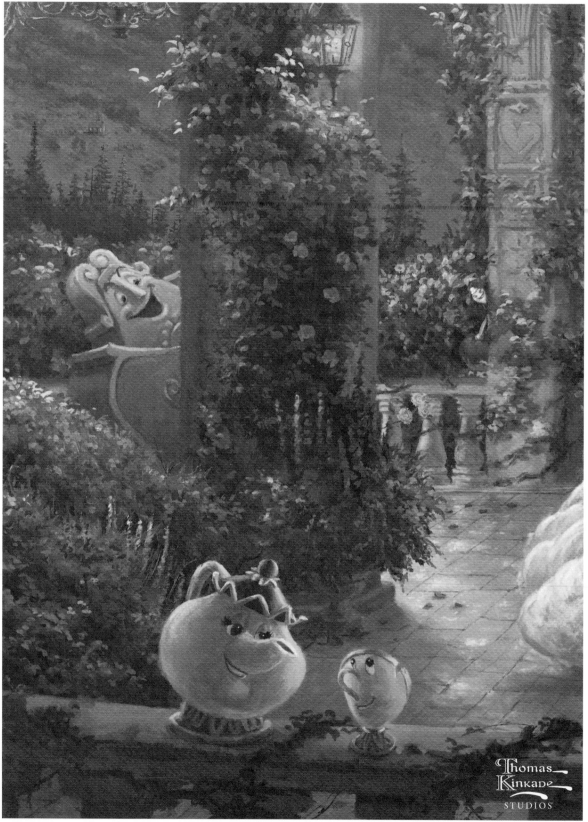

Beauty and the Beast Dancing in the Moonlight

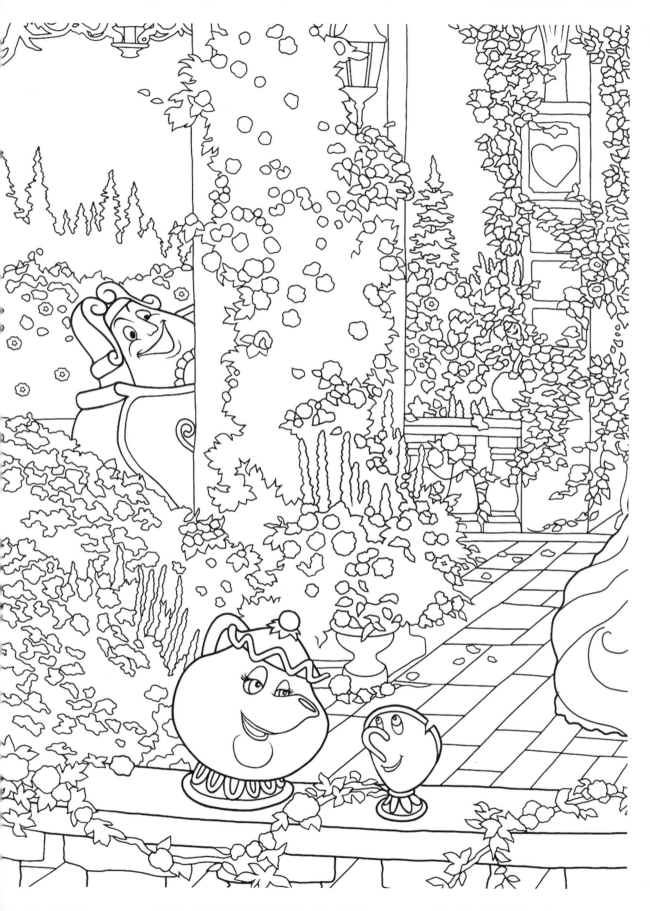

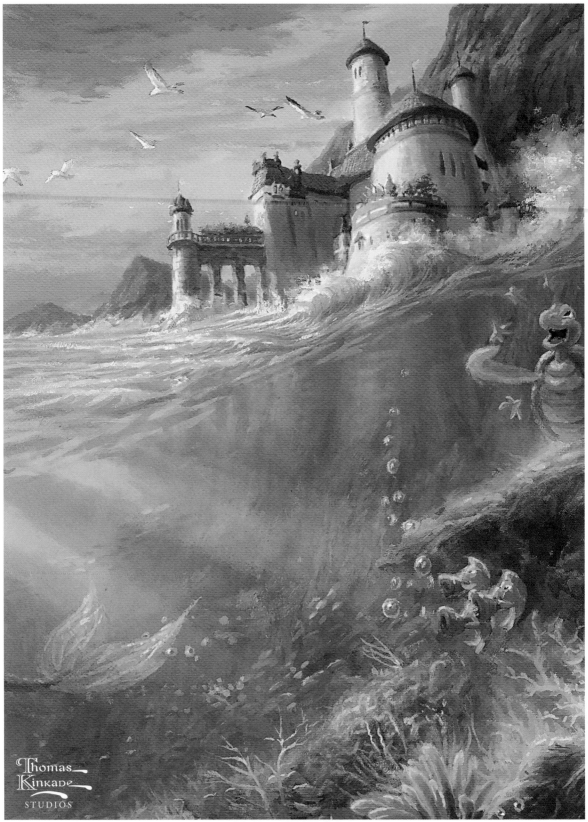

Little Mermaid Falling in Love

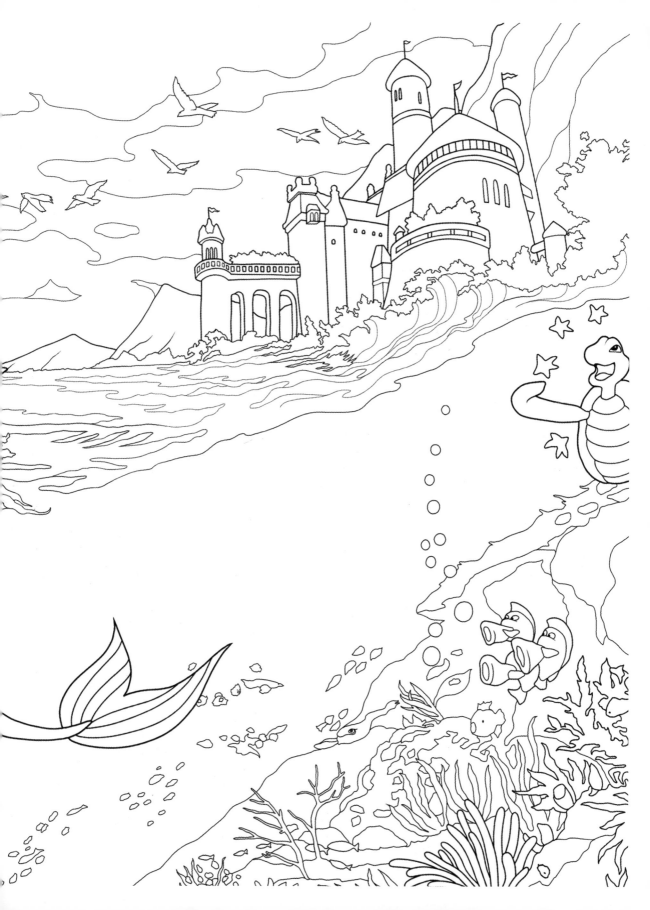

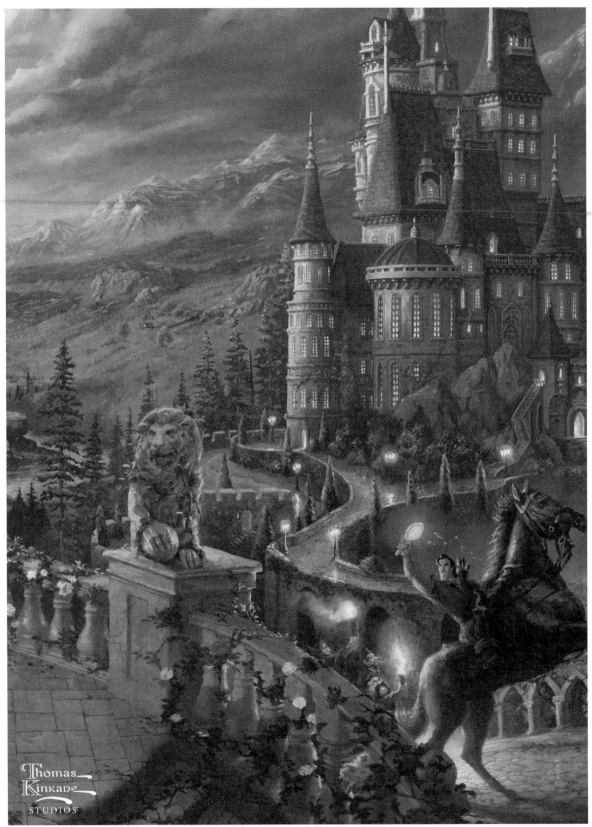

Beauty and the Beast Dancing in the Moonlight

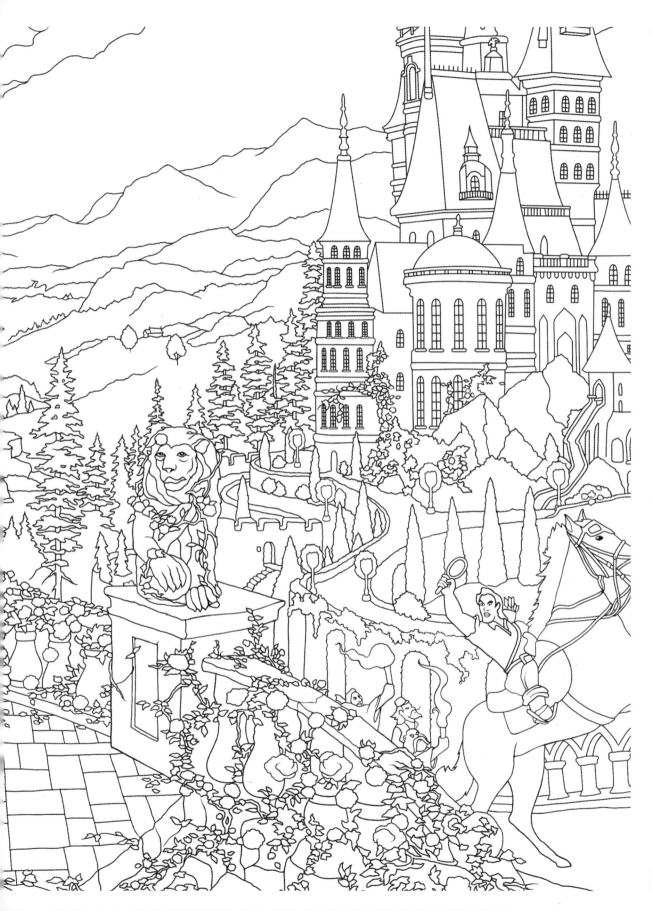

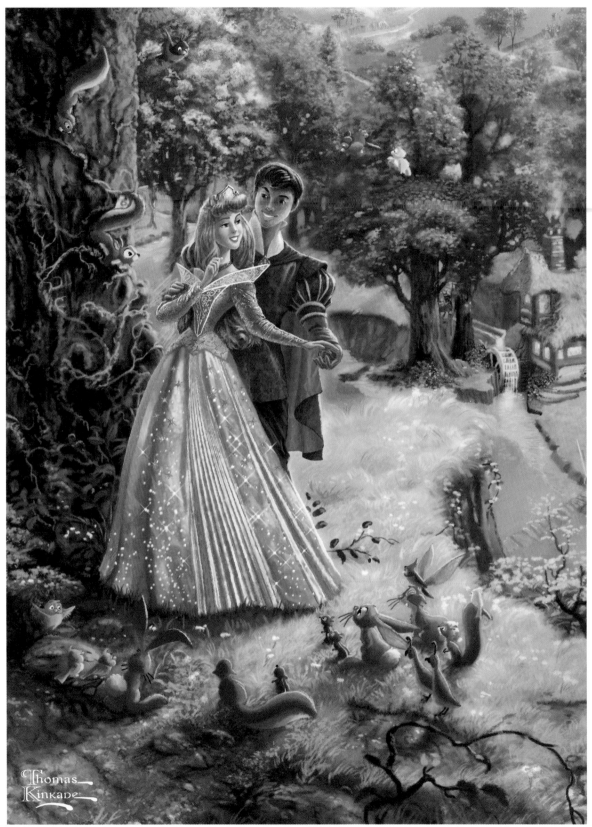

Sleeping Beauty

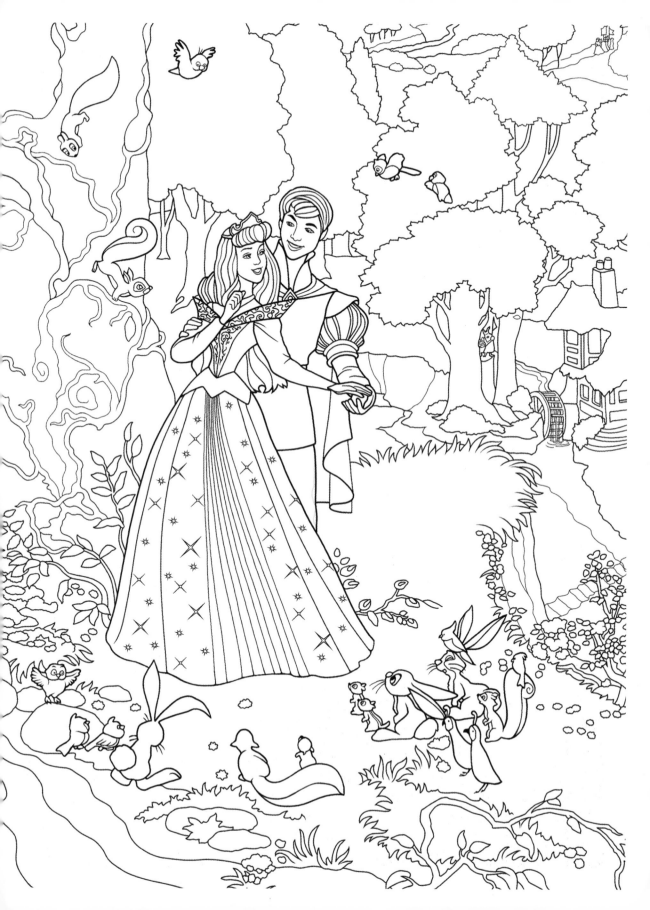

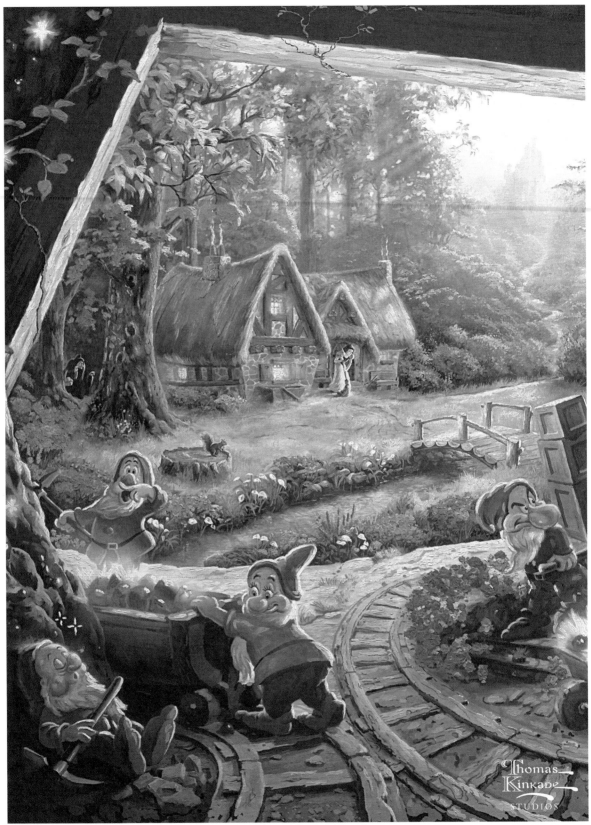

Snow White and the Seven Dwarfs

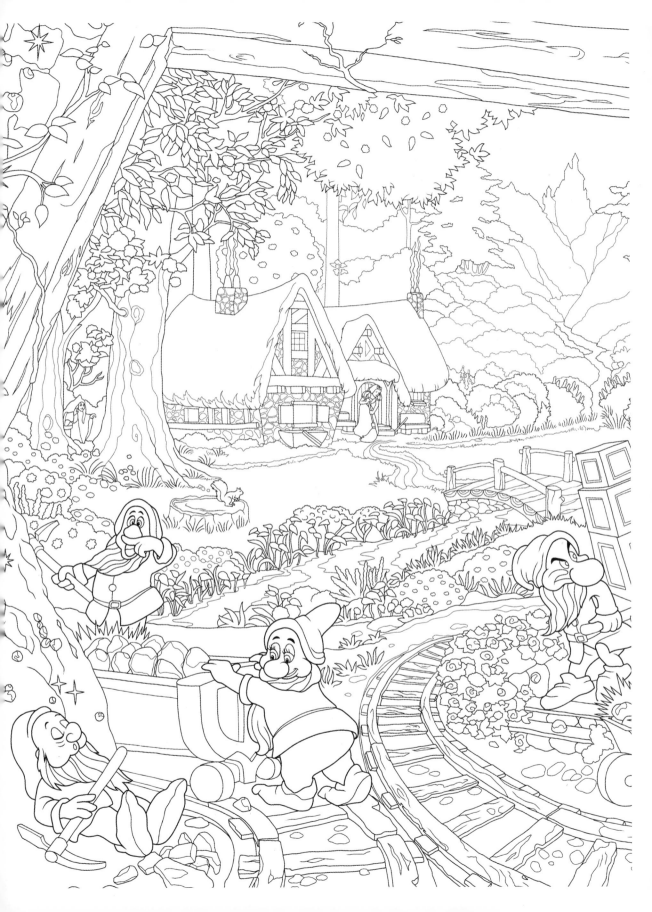

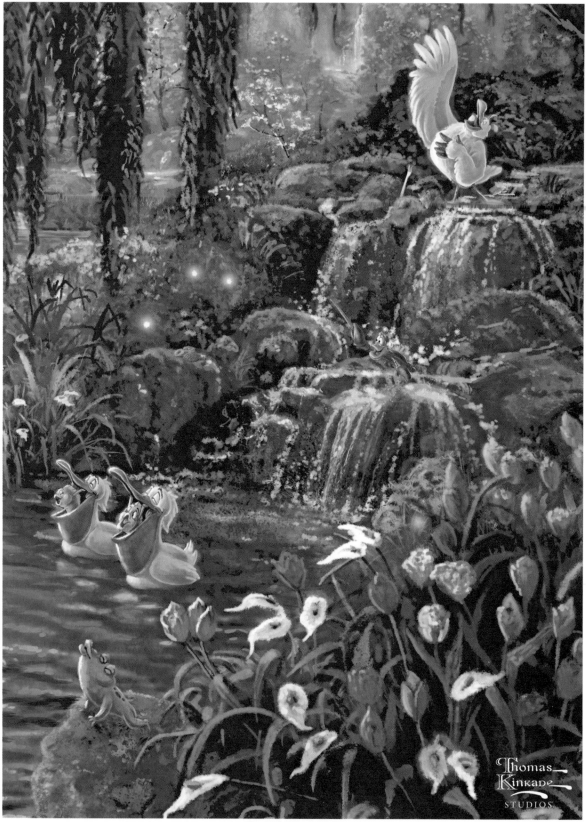

The Little Mermaid II

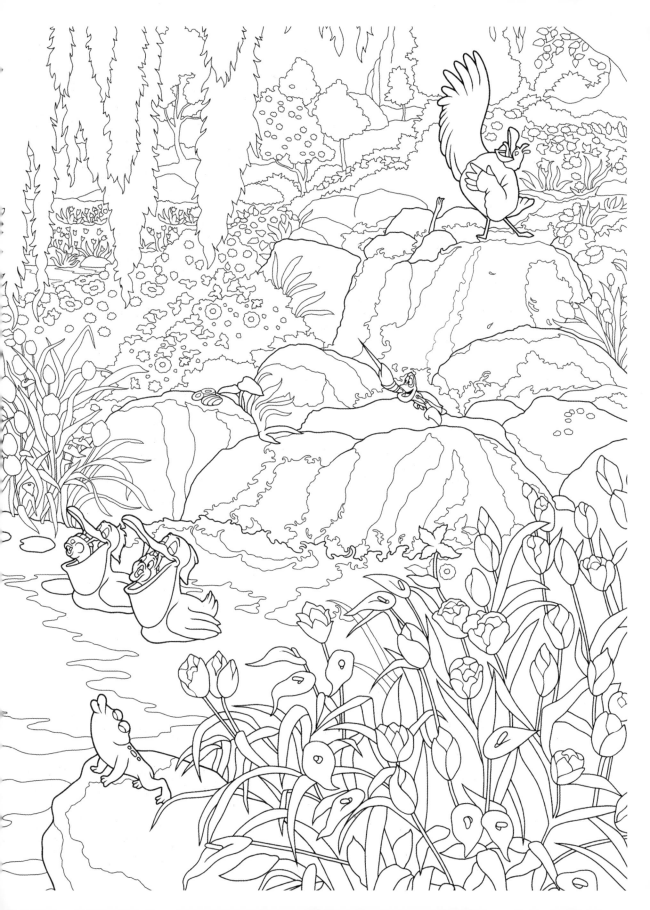

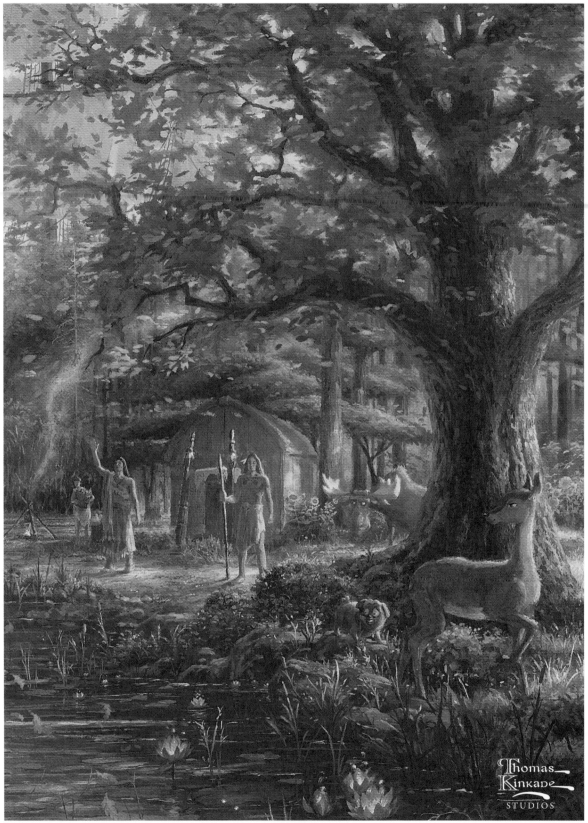

Pocahontas

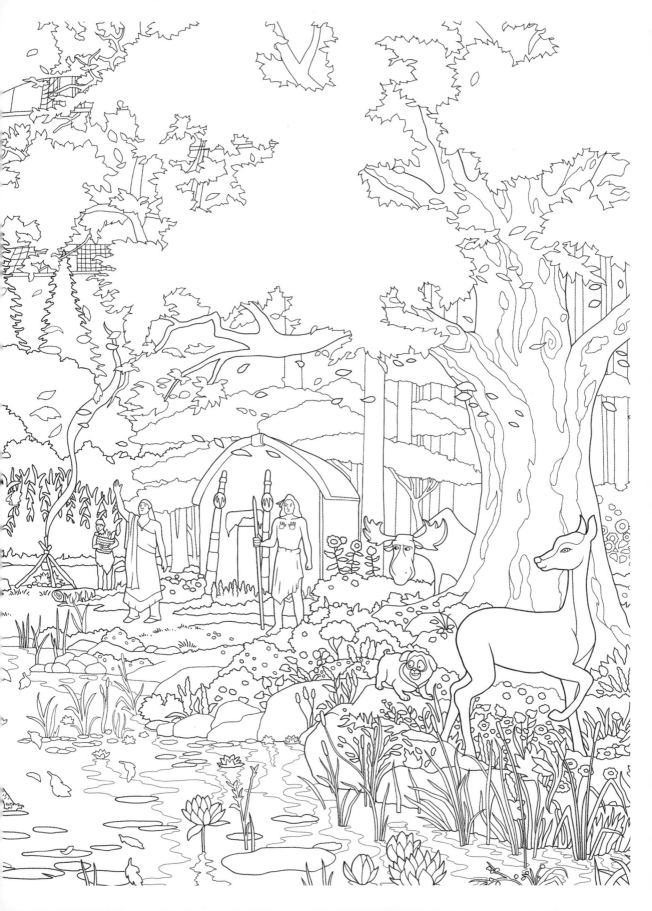

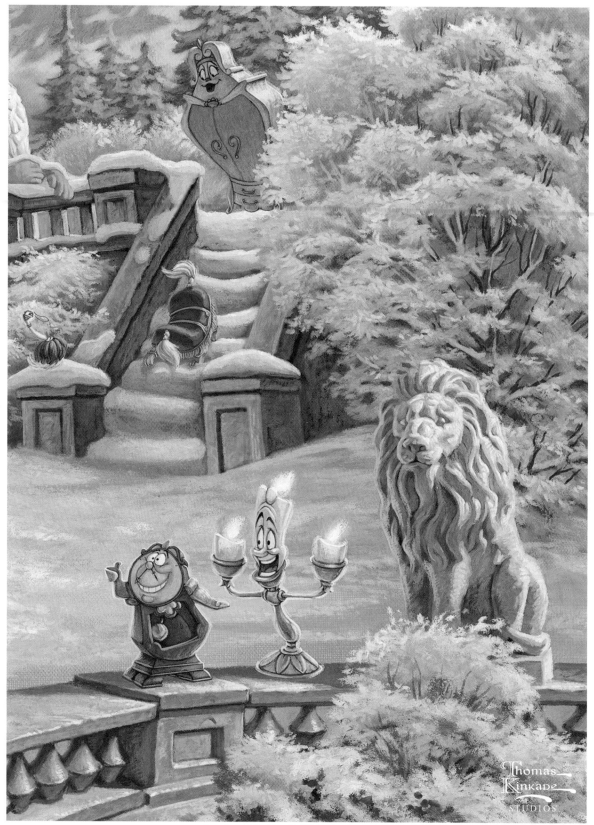

Beauty and the Beast's Winter Enchantment

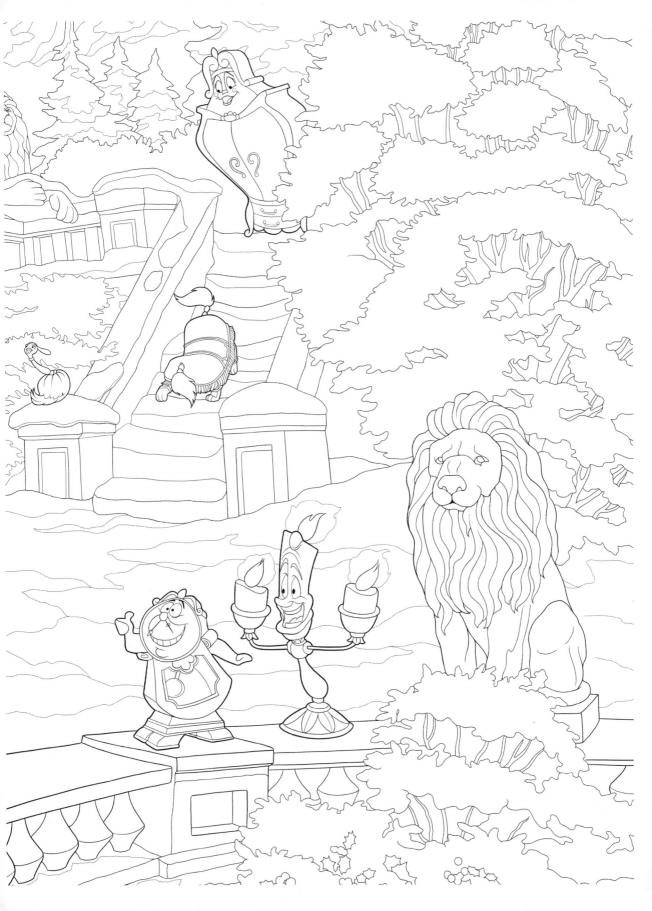

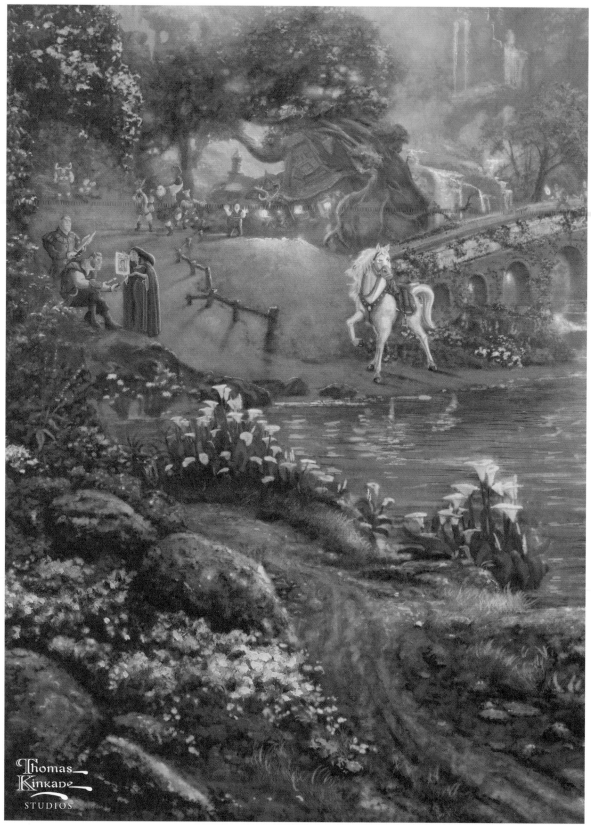

Tangled

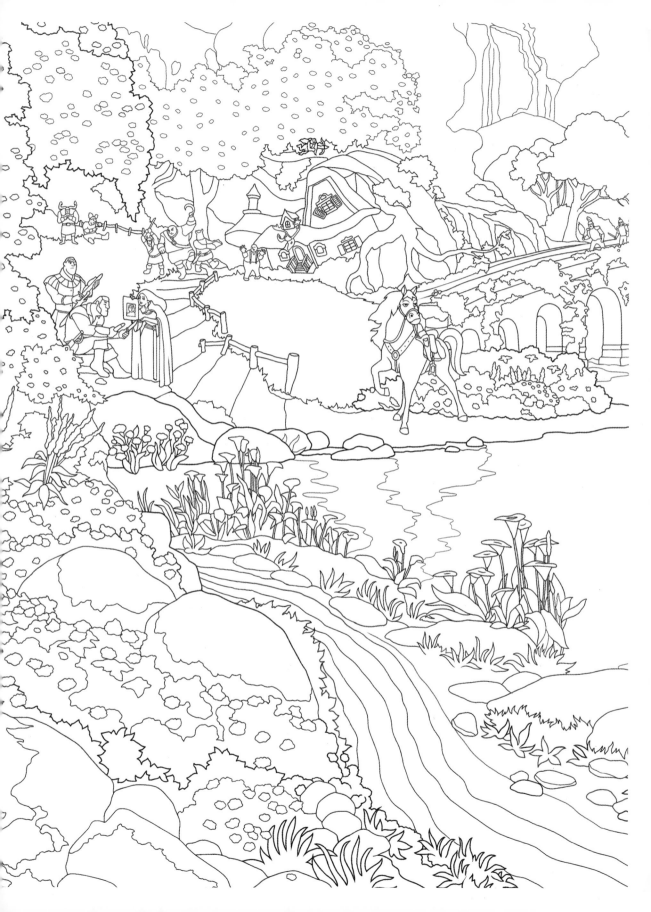

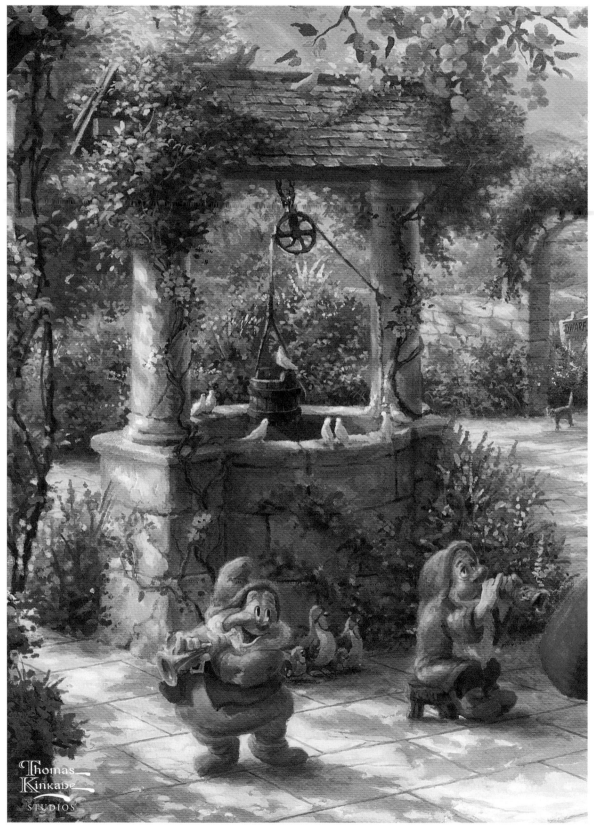

Snow White Dancing in the Sunlight

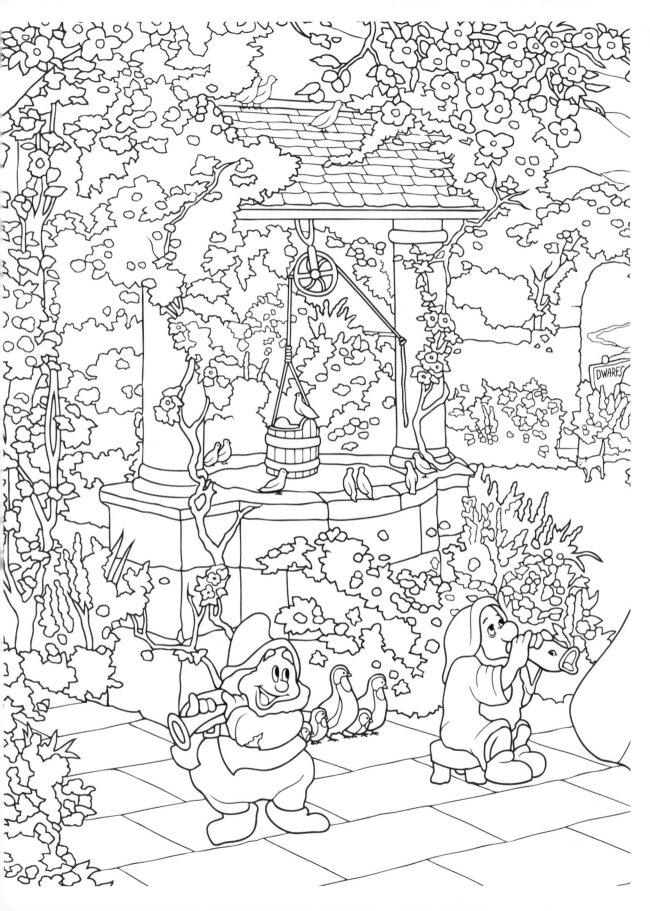

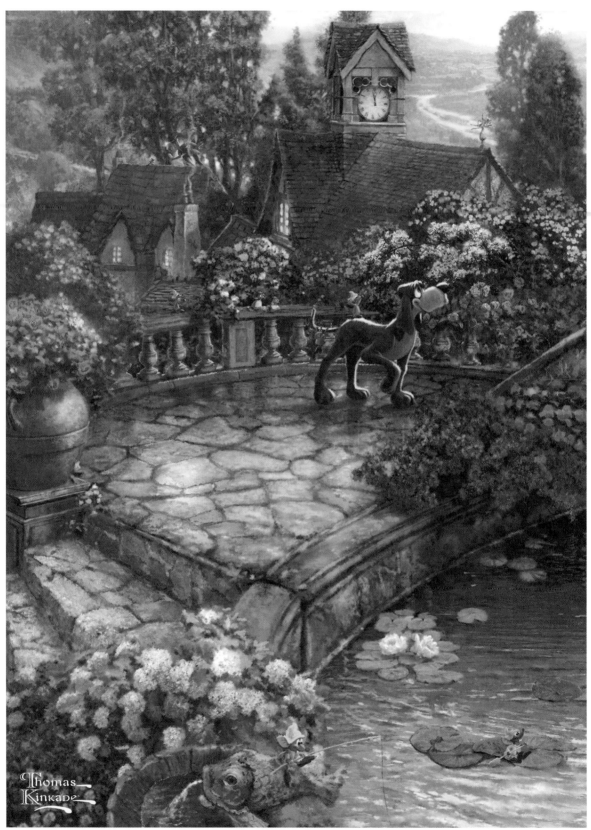

Cinderella Wishes Upon a Dream

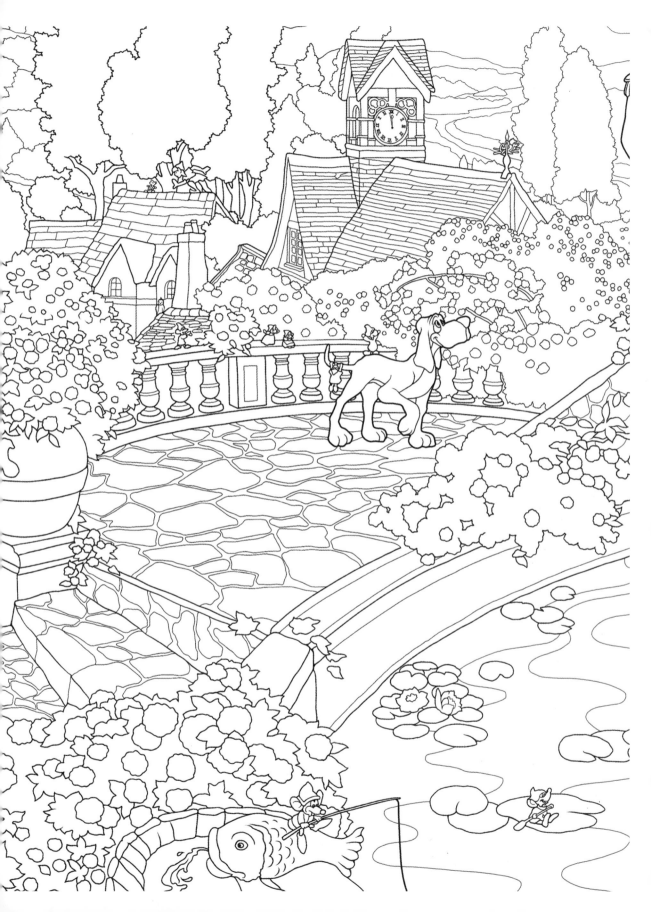

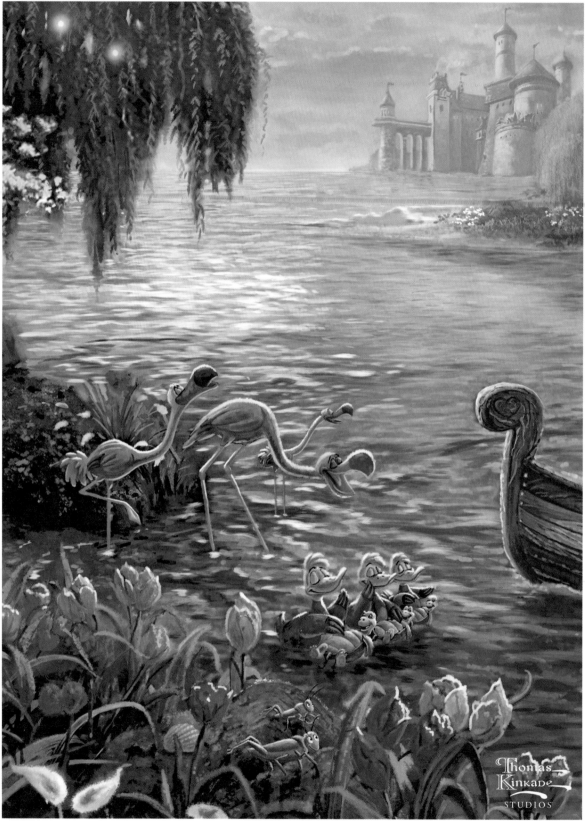

The Little Mermaid II